THE JOY
OF MOVEMENT

THE JOY OF MOVEMENT

The Fusalp Odyssey

Text by Mohamed El Khatib
With the collaboration of photographer Yohanne Lamoulère

ABRAMS The Art of Books
195 Broadway, New York, NY 10007
abramsbooks.com

Éditions
de La Martinière

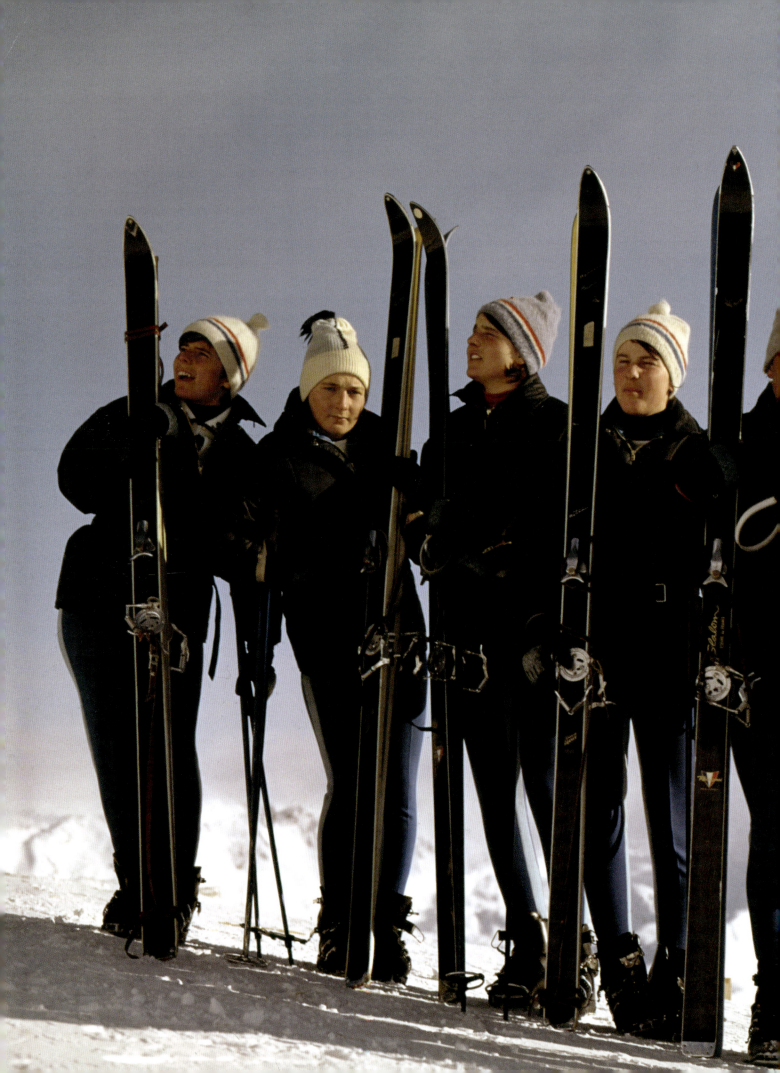

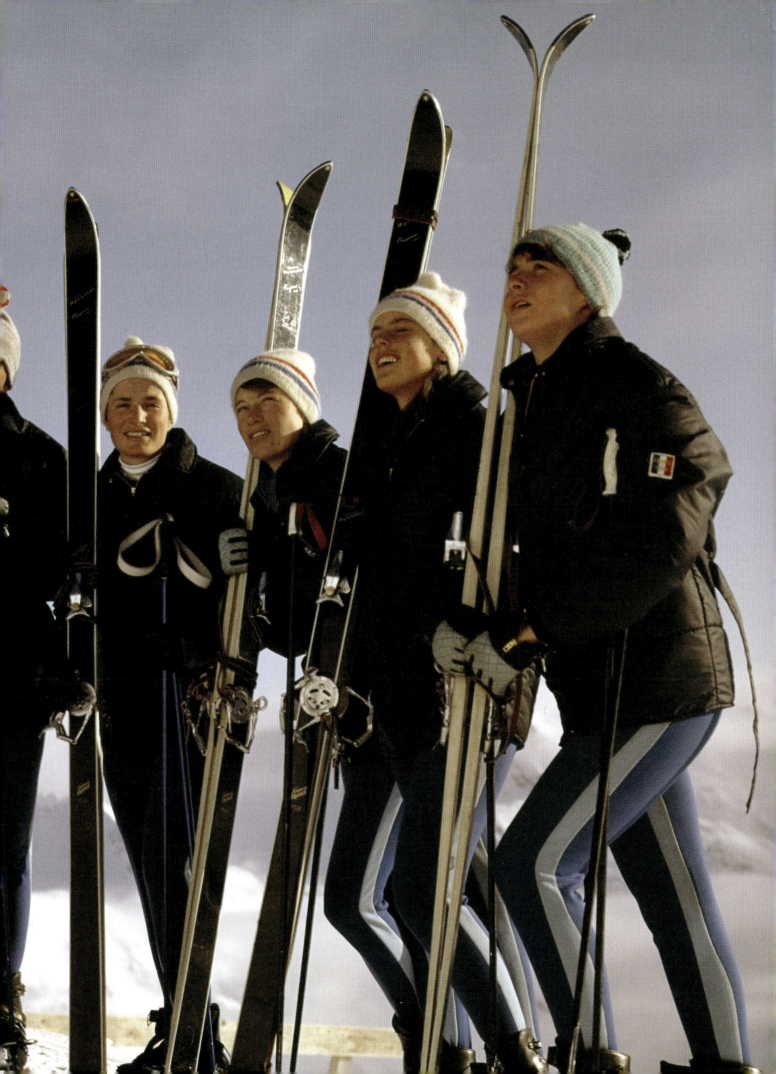

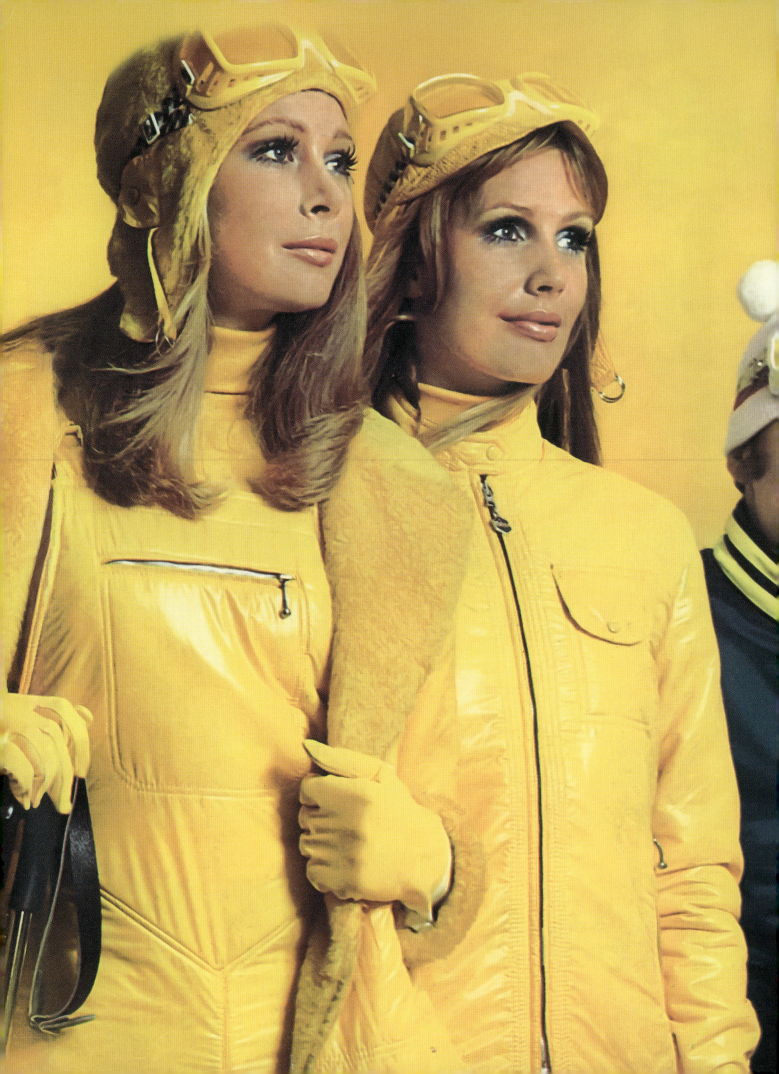

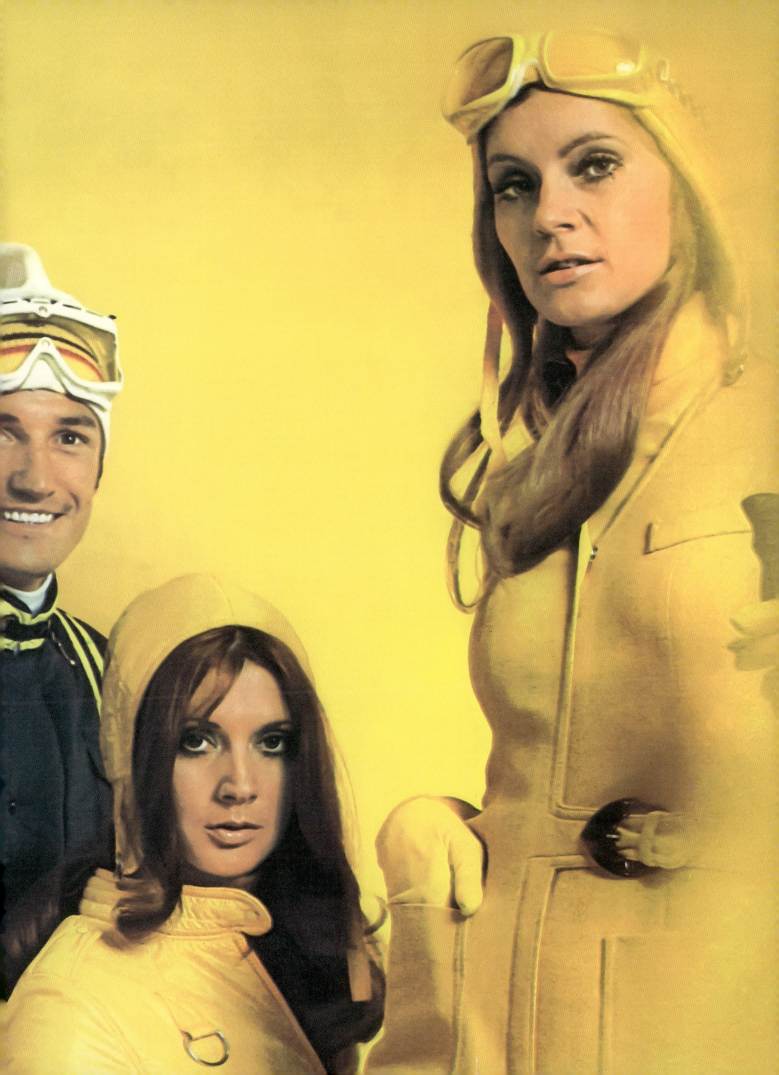

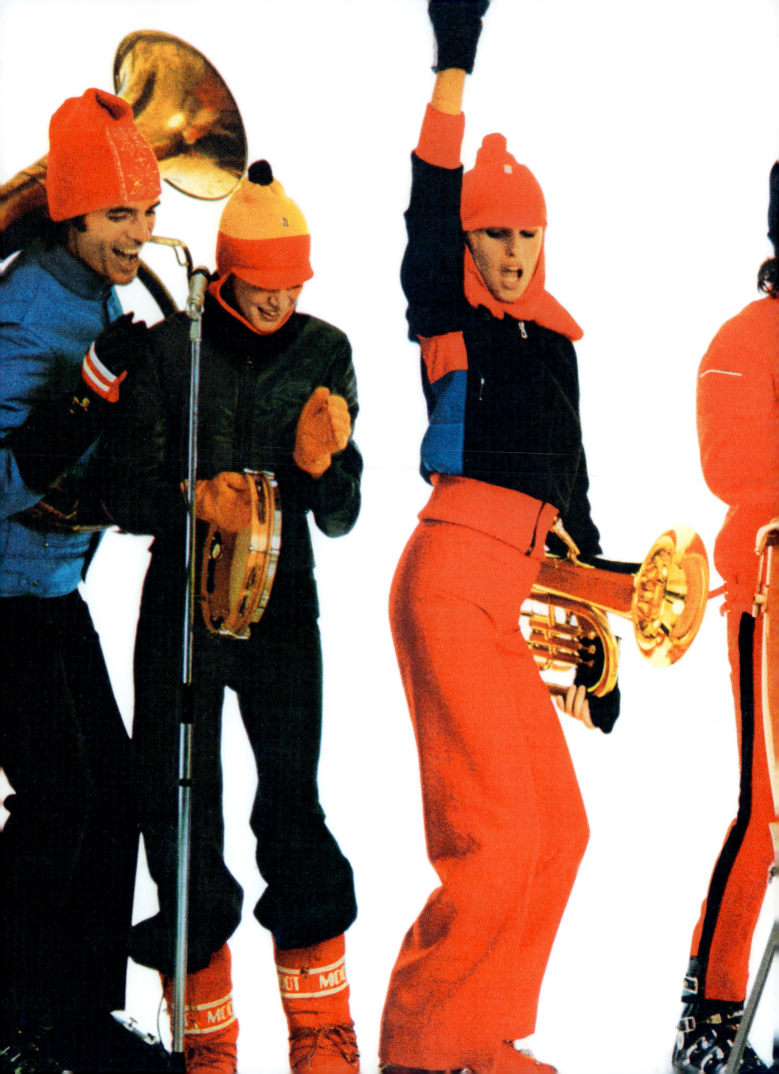

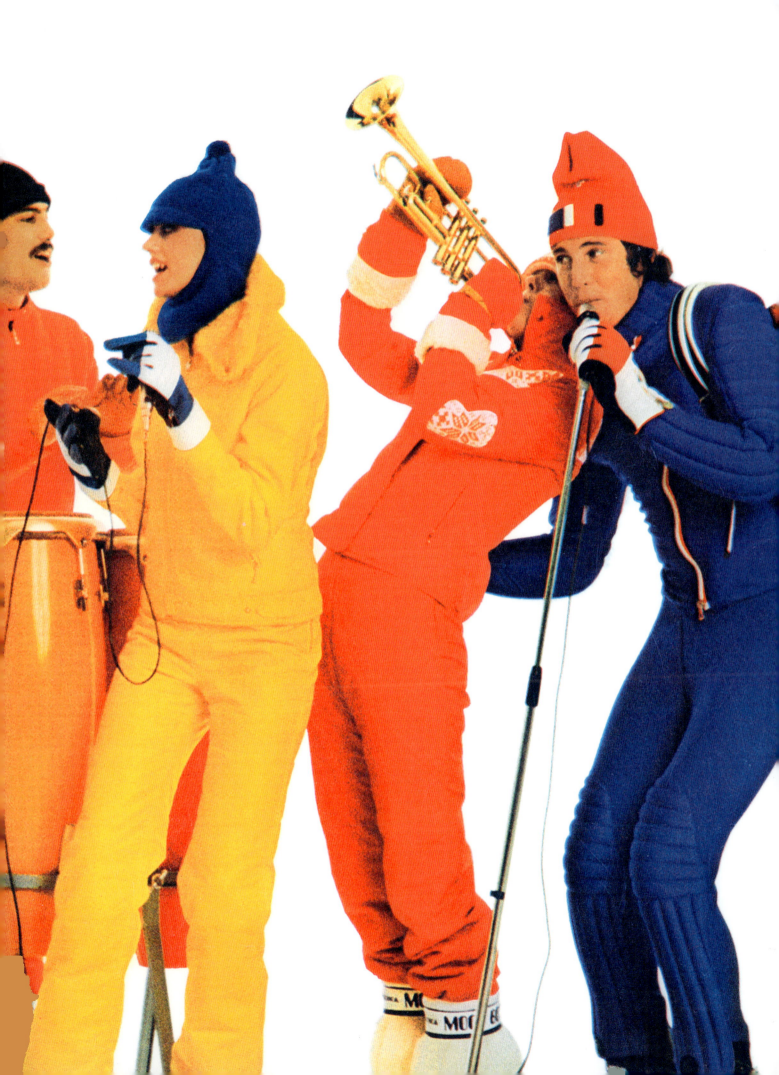

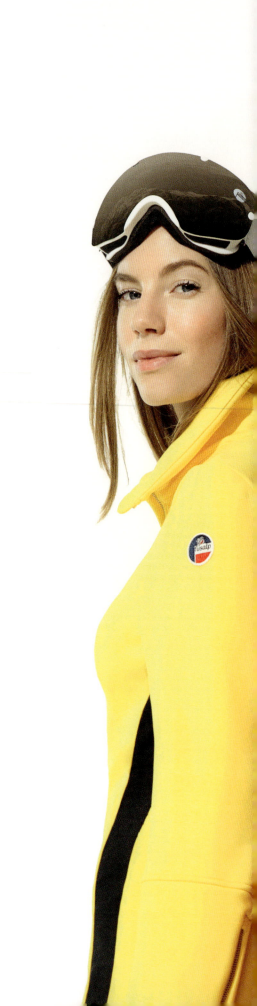

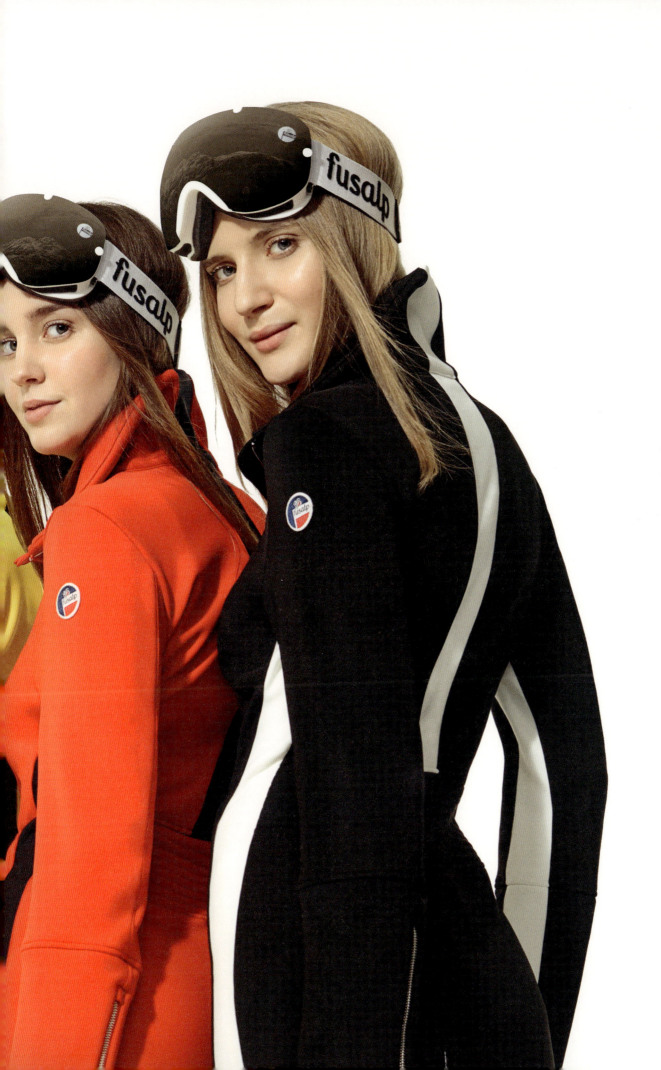

CONTENTS

14 **Foreword**

21 **Introduction**

27 **Taking competition by storm: 1952-1968**

The pioneers of stirrup ski pants
A ski brand endorsed by champions

69 **A decade of daring technique and bold aesthetics: 1968-1980**

A timeless brand with a visionary style
Brand ascent: reaching beyond borders

103 **Fusalp confronts the challenges facing the global textile industry: 1980-2014**

A wave of innovation
Toward brand rebirth

131 **Conquest begins anew: the 2000s**

Back to the roots of performance
21st century aesthetics: from ski life to street life

194 **People-centered business ethics**

197 **Fusalp's commitment**

199 **Landmarks in the history of skiing**

205 **Acknowledgements**

206 **Photo credits**

FOREWORD

We often ask ourselves, why did we choose to take over Fusalp? Why did we not create a new brand from scratch? Reason is, what really interests us is building emotional equity for a brand, tapping into the aggregate of images and impressions triggered by a brand over time. What a wonderful opportunity it is to be the guardians of a heritage born long before our time and to steer its destiny forward, knowing that we hold it in trust for future generations. Cast in the role of the ferryman, certainly, but delighted to oblige. Meeting up with Fusalp was incredibly fortunate, but it wasn't pure chance. It was destined to happen. The perfect fit.

So why Fusalp?

First, because we love skiing–that unique feel of the mountains in winter, the dry cold, the powder, that elegance that comes almost naturally when you're moving at dizzying speeds in utter silence. Alone with your thoughts, perfectly in control and perfectly at peace as you go faster still. That's what is so great about skiing, that inner calm that comes from precision movement.

Then there's the fact that we're half Savoyard on our mother's side. So when the opportunity came to join forces with Alexandre Fauvet and take over Fusalp, which is headquartered in Annecy, we jumped at the chance to speak out on behalf of a region that means so much to us. What else would you expect?

And above all, there was this bright, sharp, contemporary vision that struck us as soon as we entered the Fusalp premises. An absolute conviction, shared with our creative director Mathilde Lacoste, that here was a global brand with the potential to impact every aspect of life. The slopes, of course–that's its history and its heritage–but also the street, travel and a whole range of other sports. We knew at a glance that it was technical and elegant enough to adapt to the way we live now. And we plan to go with the flow whatever it is!

Yes, Fusalp is a great brand. A great brand because it's built on fundamental values that bring people together.

Fusalp is an authentic brand because its very identity comes from the physical demands of competitive skiing. Fusalp is an elegant brand, with an unmistakable signature focused on refined silhouettes whatever the occasion.

Fusalp is a bold brand. Always innovating to stay ahead of the times and changing lifestyles.

Fusalp is a committed brand. As committed as the skier on a steep slope slaloming between obstacles. Committed to serve its local ecosystem and reduce its impact at every level–local, global, human and environmental.

FOREWORD

But most of all, Fusalp is an optimistic brand, never taking itself too seriously, always radiating positive energy.

And so as it reaches its 70th birthday, we thought the brand deserved a celebration, and the first step should be a book. A permanent record of the brand's extraordinary history but also a book that would show us who we are so we can start building our future business today.

But not the sort of brand book that we might have read or written one hundred times already. No, this would be a book that spoke out for the people who built the brand, the people who have framed its heart and soul and made the brand what it is today. This would be a book made in their image.

For that, we needed someone out of the ordinary. Someone who could understand and listen to people, someone whose job it is to put himself in their place and grasp the full meaning of what they say.

Someone like our good friend in theatre, Mohamed El Khatib. We love bringing together the world of Fusalp and the world of artists: staging encounters with painters, dancers and stage designers to tell a captivating brand story. So when Mohamed told us about his show *Boule à Neige* (Snow Globe), we were keen to play our part from the start.

It was a show that bowled us over by its astute worldview, so much so that when it came to writing this book the metaphor of the snow globe immediately sprang to mind. And who better to write it than Mohamed El Khatib, today's French specialist in snow globes.

For the portraits, we needed a thoroughly contemporary photographer who could capture the soul of the people voicing our story. Yohanne Lamoulère is such a one: an outstanding portrait artist whose work, recording the life of the people she meets, moves us deeply.

A big Thank You to both of them!

And so here we are, inviting you to join us on our happy journey in search of epic adventures in sport, industry and entrepreneurship. An epic journey that sets out from our Savoie peaks to explore the towns of Europe, Asia and America in pursuit of the modernist, brutalist architecture from which we draw our inspiration.

Sophie Lacoste and Philippe Lacoste
Co-presidents of Fusalp

Previous double pages:
Champions gathered together in 1963: from left to right, Annie Famose, Pascale Judet, Christine Goitschel, Madeleine Bochatey, Jean Béranger (French women's team coach), Christine Terraillon, Florence Steurer, Cécile Prince, Cathy Cochaux.

Fusalp proves its pioneering credentials with fashion styling and daring color choices, 1968.

Fusalp at the beginning of the 1990s: uncompromising technical excellence and a style of pure joy.

How the Fusalp DNA runs from collection to collection: here, the autumn-winter collection of 2017-2018.

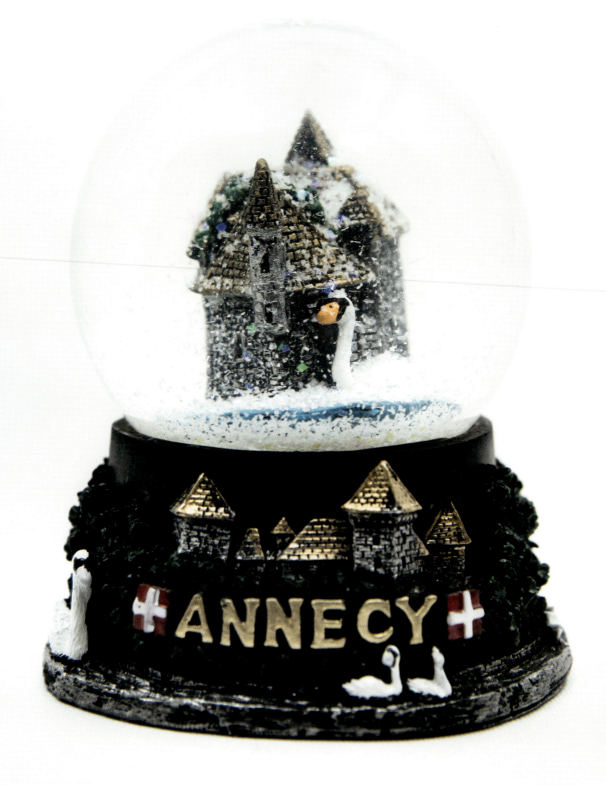

INTRODUCTION

Fusalp is 70 years old

Fusalp is 70 years old.
70 years of technique and elegance.
70 years of performance in the service of the greatest skiers of all time.
70 years of an industrial commitment that was born in Annecy and has since revolutionized Alpine ski wear, giving winter wear its credentials thanks to bold designs that never go out of style.
Like most good stories, this one starts "once upon time."
That time was childhood–the time when dreams are born and passions take root, the place where it all begins.

Once upon a time there were two visionary tailors named Georges Ribola and René Veyrat who lived in Annecy, in Haute-Savoie. Little did they know that in the 1950s, just as French Olympic skiers were making their comeback, they would come up with a new idea: the *fuseau*, stirrup ski-pants that would take the slopes by storm. Within a few years skiers sporting Fusalp (a fusion of *fuseau* meaning spindle, and "Alps") would reap the biggest ever harvest of Olympic gold medals. Within a few decades the label created by our two tailors from Annecy would be equally at home on the slopes and on city streets, its distinctive designs as timeless as ever.

That timeless quality has endured over time thanks to the generations that followed; but it also bears the hallmark of Ingrid Buchner and Mathilde, two women with their own unmistakable style.

Previous two pages:
View of Lake Annecy, cradle of the brand in the Haute Savoie.

The story of Fusalp is a story steeped in the emotions attached to memories of childhood–our first winter vacation, our first outing on skis, our first epic snowball fights and the first *fuseaux*

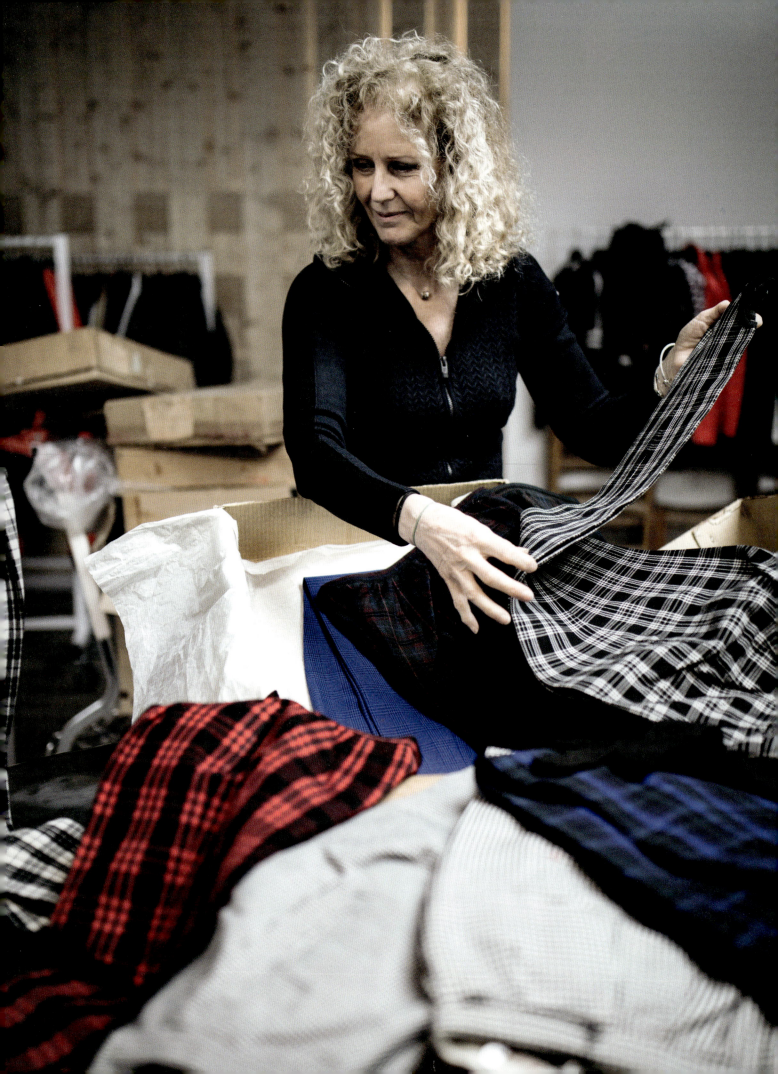

INTRODUCTION

Diving into the archives triggers a surge of nostalgia–a yearning for those carefree days of childhood that discovered the joy of softly falling snow. Fond memories come thick and fast, family stories blending into warm recollections of tender moments. A long-vanished beauty flashes before your eyes, as if trapped in a snow globe. So just like a child, you shake the globe to make the past reappear and carry you away amid a flurry of whirling snowflakes.

This book works the same way, retracing our heritage to transport you to another place and time. Featuring pictures from the company archives and words by the people who built the brand, it revisits the century that sparked the birth of the industrial aesthetic behind the Fusalp label. With it came a signature ski look that defined the skier of yesterday and fearlessly embraced street culture to shape the fashion of tomorrow.

The archaeology of tenderness

It is 1 April 2021. A pallet arrives at 114, Avenue de France in Annecy, the beating heart of Créations Fusalp. It contains the kinds of boxes they don't make any more so everyone is curious to see what's inside. Nadine Portigliati, doyenne of Fusalp, decides to find out.

The first label is marked "Maison Chomette, Saint Etienne"–a store that no longer exists. It turns out that the boxes date from 1952 and contain the very first series of technical pants (forerunners of modern stirrup ski pants), all in surprisingly good condition. It's a moving moment for Nadine and the team, reminding them of the timeless nature of their brand. Before them is spread a collection of clothing that goes back to the early days of Fusalp, starting with experimental designs such as "Fizz" pants: pants that fitted over boots, with an elasticated band for unrestricted movement. In other words, state-of-the-art ski wear for the French ski teams of the time. All of these pants were created by Georges Ribola and René Veyrat and what's striking about them is the quality of workmanship but also their elegance. These are items of clothing you could easily wear today, proof that masterful technique is the art of doing things well.

Nadine Portigliati, doyenne of the enterprise, discovers the vintage treasure trove sent by La Maison Chomette to Fusalp headquarters in Annecy, 2021.

INTRODUCTION

Included in the package is the following note from the store's former owner: "Your boxes were good and strong, and so were your pants!"

Another journey through time, this time at higher latitudes, took place recently in Oslo. Alexandre Fauvet, CEO of Créations Fusalp, went to Norway for the launch of Fusalp's "Young Champions Program," which provides mentoring for budding ski talent. It was here that he came across Norway's young hopeful, Kaspar Kindem, who turned up wearing a favorite jacket formerly belonging to his grandfather, mumbling excuses about being in such a rush that he had forgotten to bring his uniform. This is going back 40 years to the time when there was no logo on the outside, just a discreet zipper pull displaying the name of the brand. We are delighted to know that this young man has taken such a fancy to the jacket left him by his grandfather – as stylish today as it ever was.

It is this legacy of the past that is the essence of Fusalp–a brand dedicated to the art of movement. This in turn depends on technical, high-performance materials to ensure comfort and complete freedom of movement; and an aesthetic approach that defies time and space to create an item of clothing that speaks to the heart.

And so the snow globe metaphor still holds true. Items that connect the present with past emotions open up a place of dreams where innovation is born.

> **"Your boxes were good and strong, and so were your pants!"**
>
> *FORMER OWNER*
> *OF A FUSALP BOUTIQUE*

Stirrup pants from 1953, found as good as new at the back of a boutique in Saint-Étienne, Annecy, 2021.

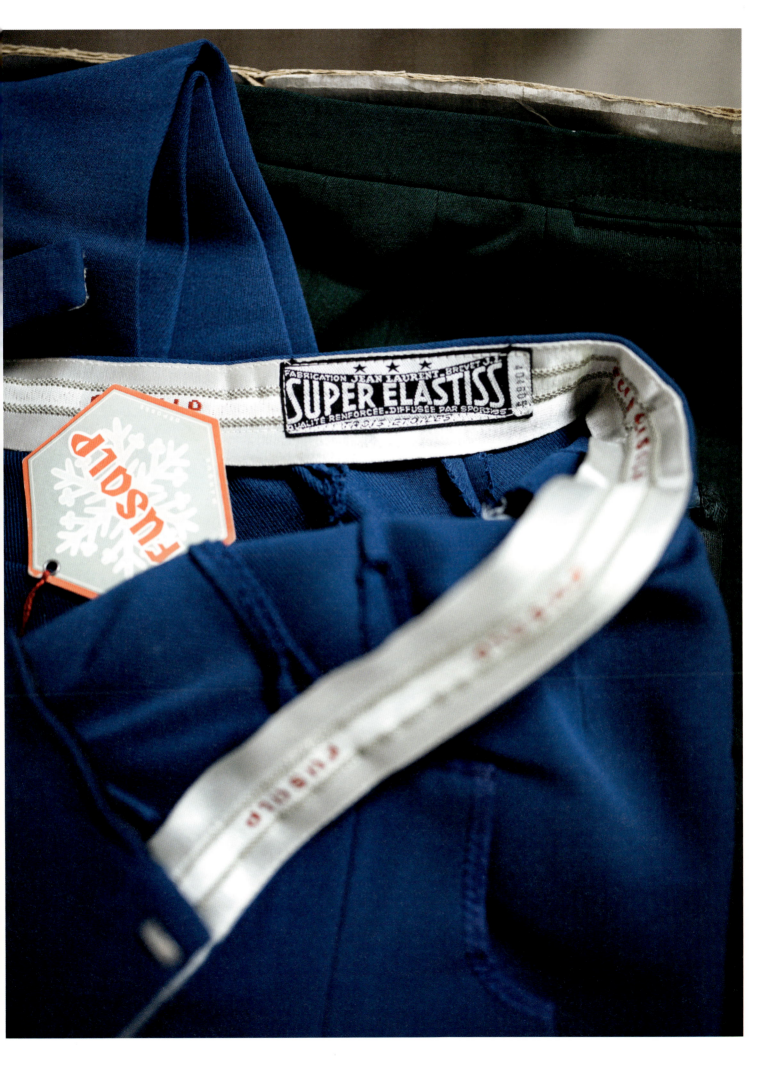

Taking the competition by storm

1952 - 1968

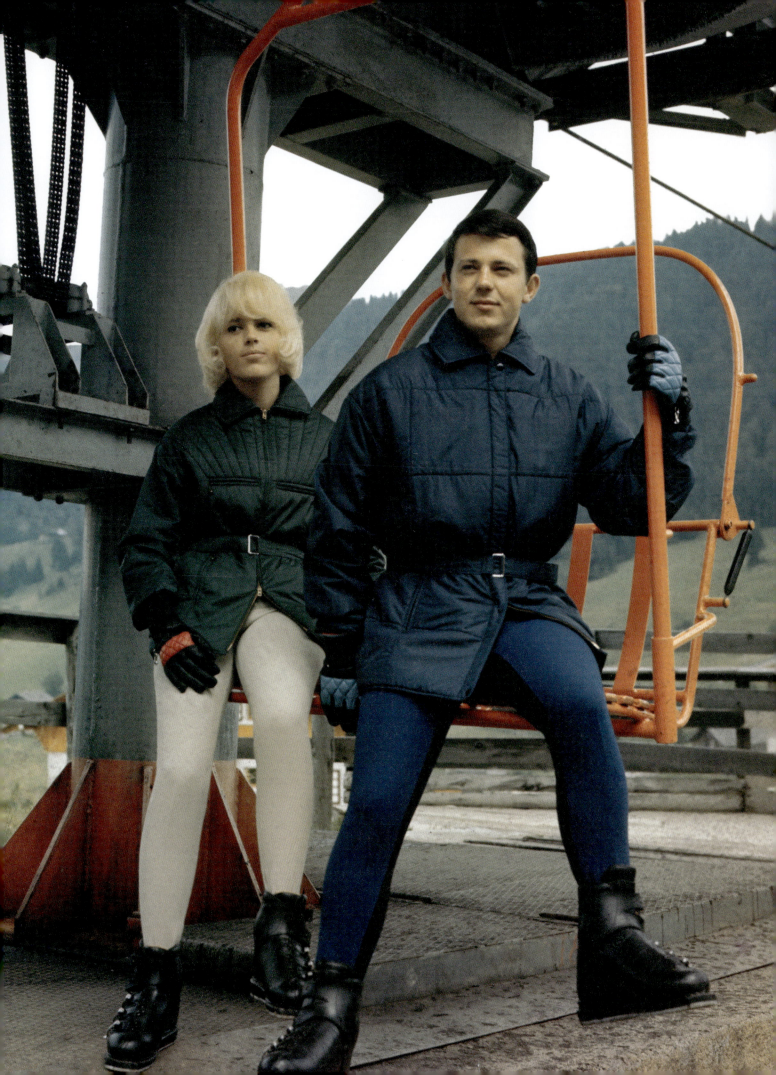

The pioneers
of stirrup
ski pants

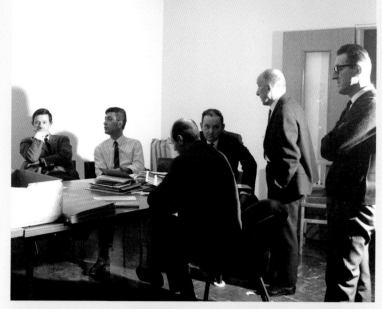
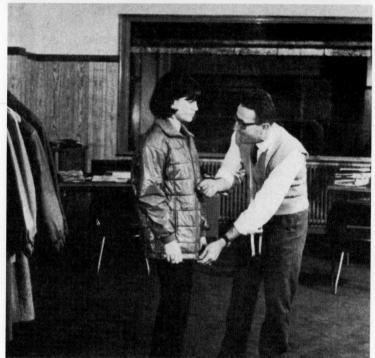

THE PIONEERS OF STIRRUP SKI PANTS

In the late 1940s, entrepreneur René Veyrat set up a men's tailoring workshop in the Avenue de Loverchy, Annecy. This was in that period of intense creativity in the garment industry that witnessed the shift from made-to-measure to ready-to-wear. Among the members of Veyrat's tailoring team was Georges Ribola, a talented young craftsman whose work already displayed a singularly elegant style. After training as a cutter, Georges finished top of his class and went to work for René Veyrat. It was his job to cut fabric to a pattern, so producing the panels that made up the finished garment. But the rigid conventions of custom tailoring did not sit easily with this stonemason's son from a hamlet in Chamonix.

He quickly tired of churning out formal men's suits and longed to return to his first loves: sport and the mountains. So Georges, the creative, suggested to René Veyrat, the entrepreneur, that they launch a new clothing line: *fuseaux*, or stirrup ski pants. As a skier himself, Georges had an intuitive grasp of what skiers needed in terms of shapes and materials for optimal performance whatever the terrain or conditions. So it was that he quickly became recognized for an excellence in tailoring that laid the foundations for Fusalp: a brand born in 1952, in the heart of the French Alps.

Technique was the guiding principle behind this alliance of conceptual and manual skills. The 1950s witnessed experiments in textiles and materials that made it possible to create skin-tight, stretch competition wear for improved athletic fluidity.

For Geoges Ribola, every constraint related to performance posed a new challenge to his skills as a tailor. The first stirrup ski pants were held in place under the foot and tucked into ski boots, which at the time were low-rise, allowing snow to enter over the top. So in 1955 he came up with his first innovation: ski pants that fitted over the boot, held in place by hooks and a leather strap. Eventually however, working with members of the French ski team, he saw that his pants caught the wind on the descent, decreasing the skier's speed. That was his cue to develop figure-hugging pants in bright colors (sky blue, yellow ...), which skiers initially found too revealing but quickly adopted for their technical advantages.

The stakes were high at a time when skiing took center stage in the sporting media and every competition was won by the Austrians or

Previous two pages:
A freshly prepared piste in the Annecy area.

1968: no snow but Fusalp stays right on course! Unable to afford models, sales director Claude Lavorel poses with his friend Sylvie Vala.

Left top:
Team meeting with Fusalp founder René Veyrat (1969). From left to right, Claude Lavorel, Roger Veyrat, accountant Blanchet, Georges Ribola (seen from behind), René Veyrat and model maker Monsieur Trabujo.

Left center and bottom:
Working on the fit with a member of staff in 1971, under the watchful eye of Georges Ribola.

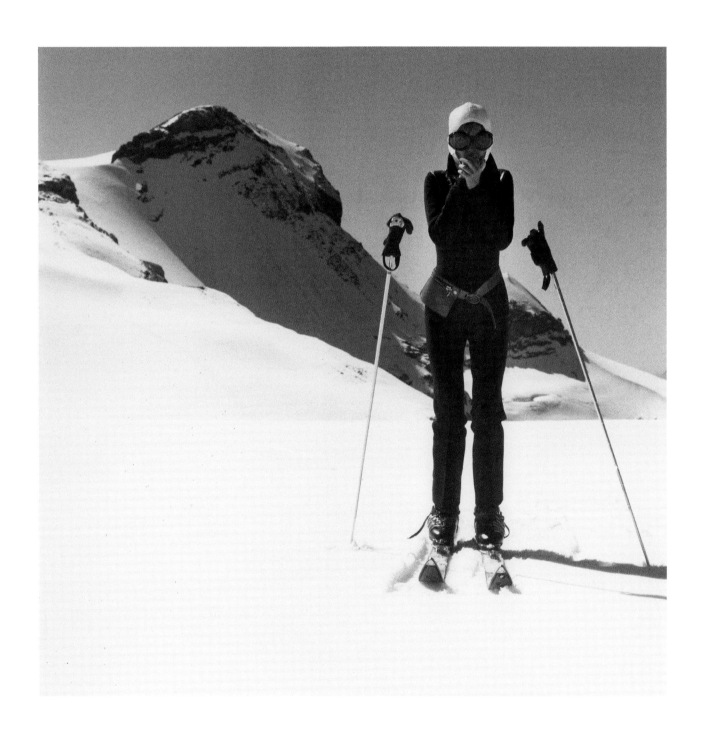

THE PIONEERS OF STIRRUP SKI PANTS

the Germans. While credit must go to the Mégève farmer boy, Armand Allard, for inventing the very first French, Austrian-inspired *fuseau* in the 1930s, it was Georges Ribola who revolutionized their design 20 years later, based on a brilliant idea straight out of the Wild West.

The first stirrup ski pants were made of *tricotine* and gabardine–so not very stretchy. It was Georges Ribola who thought of using new fabrics such as Helenca: a more flexible material then under development at Lyon-based supplier Sportiss. Lycra was even more flexible and had just come onto the American market. But there remained one big problem: to reduce wind resistance, a *fuseau* had to be so tight-fitting that it cut off blood flow. These new textiles only stretched in one direction, crosswise; to improve athletic fluidity, ski pants had to stretch in two directions, crosswise and especially lengthwise.

Story has it that Georges solved this sartorial conundrum while watching one of his favorite western movies. This was a cavalry western, and it was the stripe down the leg of the cavalry pants that gave him the idea to add a flexible side band to his ski pants. It proved a game changer. Henceforth, ski pants stretched in two directions, crosswise and lengthwise, revolutionizing performance on the slopes.

These and other technological breakthroughs eventually persuaded the French Ski Federation to request that our two Savoyard tailors should dress the French ski teams, to help improve their downhill times. And with that, the *fuseau des Alpes* was on its way to conquering the world's highest peaks–constantly evolving to achieve uncontested dominance in its sphere.

Georges Ribola was an exceptional creative thinker with a talent for surrounding himself with the right people. Among them were family members, such as his wife Luce, a prototyping specialist who worked closely with her husband in various areas; and his nephew, Claude Lavorel, who was privileged to witness Georges' golden years. "He was like Yves Saint Laurent only more so. Because in addition to designing and making sample garments all day, Georges also managed the production line. Every morning all of the foremen would gather in his office so he could check the manufacturing process from start to finish! And sometimes–well let's say, he knew how to get what he wanted …."

Previous two pages:
The sky sparkles for Fusalp in the 1960s and reflects its colors.

Performance plus sport-chic elegance: the Fusalp signature.

Right:
The celebrated starred braces, inspired by cavalry trousers in westerns.

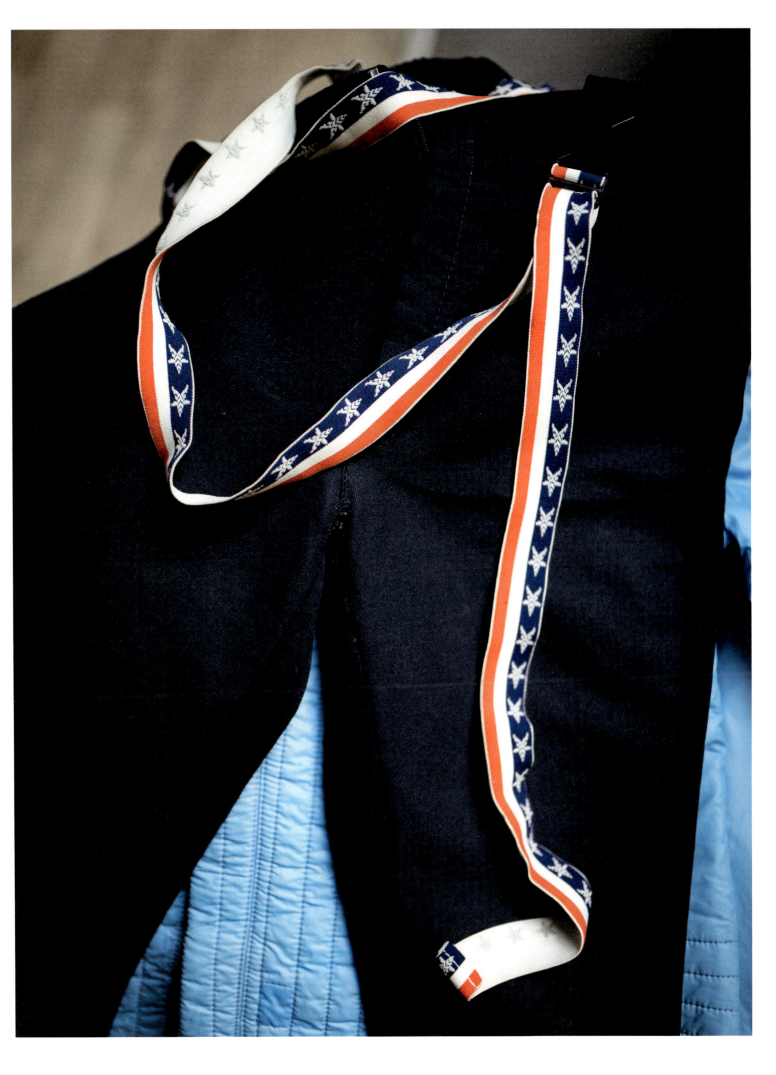

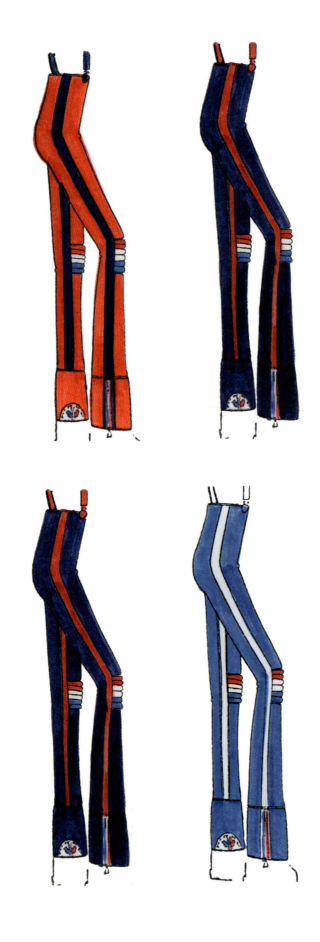

THE PIONEERS OF STIRRUP SKI PANTS

Stirrup ski pants, anoraks, competition clothing–an ever-wider range of sportswear saw the need to step up the pace of production to meet rising demand. And since it was impossible to find enough employees in Annecy, what started out as a craft-based business operating out of a workshop in the Avenue de Loverchy morphed into a prosperous enterprise boasting a bevy of newly-opened factories in Savoy, the biggest one in Albertville.

> **He was like Yves Saint Laurent, only more so. Because in addition to designing and making sample garments all day, Georges also managed the production line.**
>
> CLAUDE LAVOREL

Building a strong brand image

Together René Veyrat and Georges Ribola came up with a new take on stirrup ski pants that revolutionized skiwear. But their Annecy adventure must be seen in the context of a political climate ripe for social change. France's Thirty Glorious Years were marked by strong economic growth and an overall improvement in the standard of living. Paid vacation days, shorter working hours and increased mobility saw the democratization of winter sports. The mountains went from being places "to take the cure" to places for recreation, attracting a whole generation of the middle-class French. Henceforth, the pleasures of ski resorts such as the Rothschilds' retreat in Mégève were no longer reserved for the elite. The 1960s and 1970s then marked a building boom that saw a string of purpose-built resorts spring up in the Alps, attracting new customers and shaping a society grounded in greater freedom for all. With it came new demands that spurred the introduction of ready-to-wear winter clothing and the birth of new brands specializing in sportswear and leisurewear alike.

Left:
Designs by Ingrid Buchner for the autumn-winter collection of 1976-1977: setting out the range of Fusalp colors.

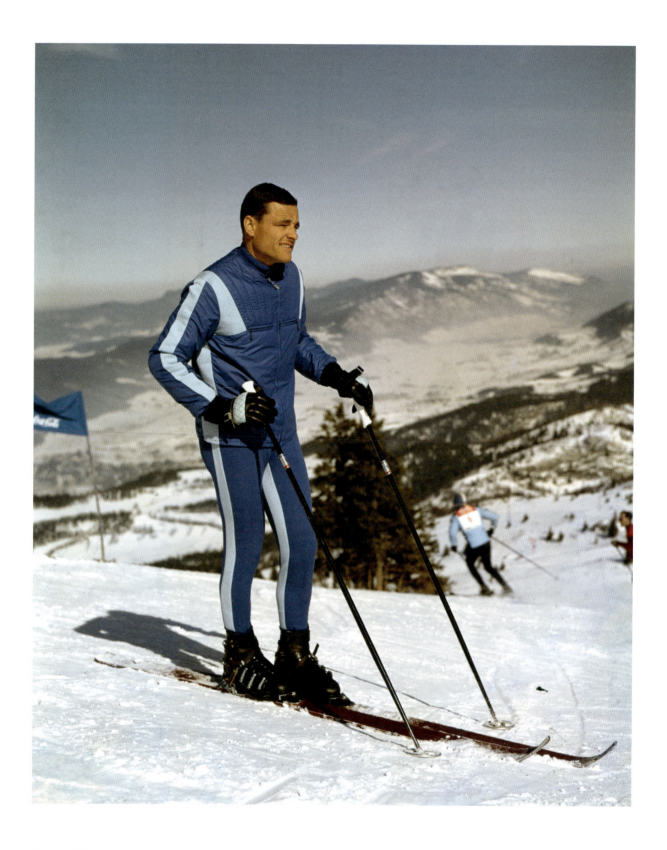

Series of ektachrome prints from the late 1950s: competition wear, sportswear, Christmas in the Alps—Fusalp colors brighten up the snow.

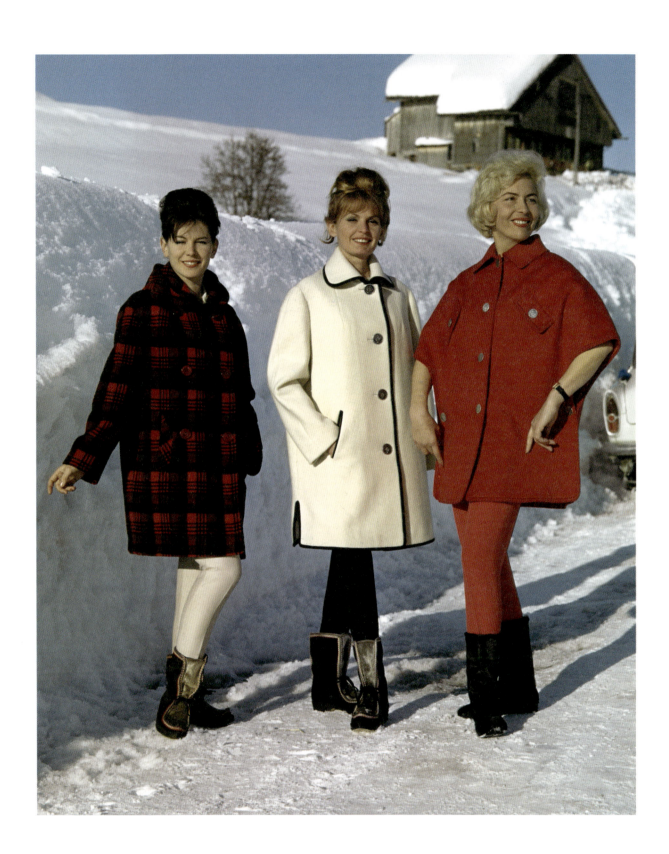

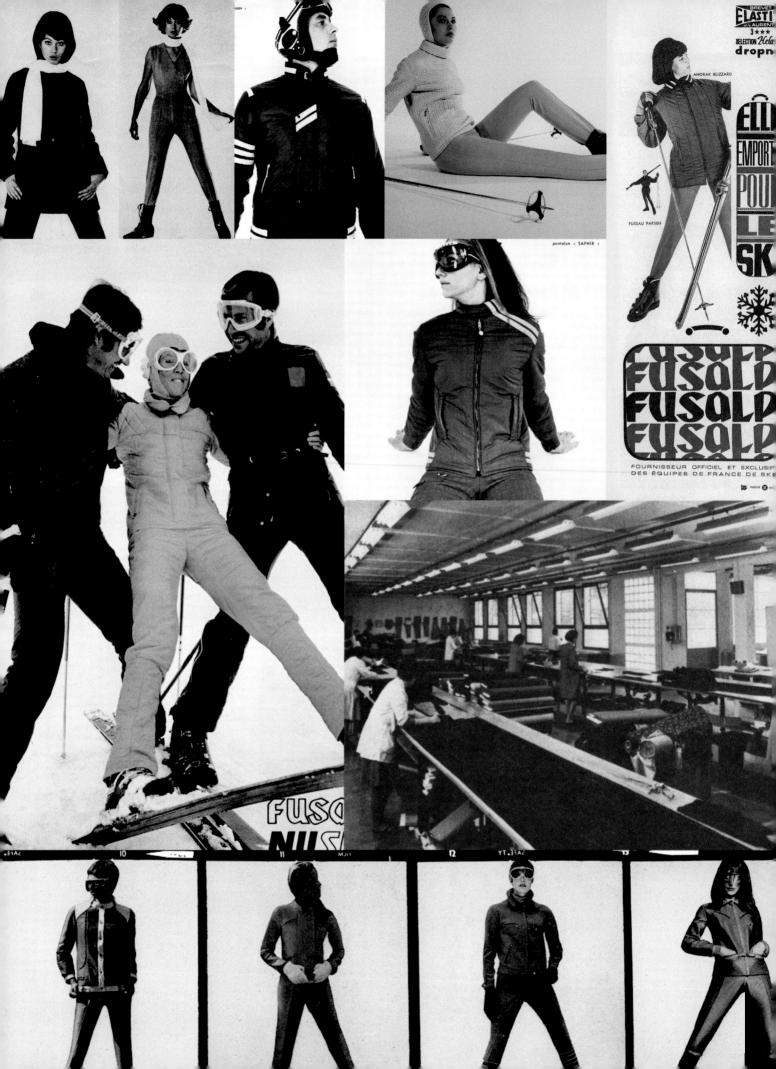

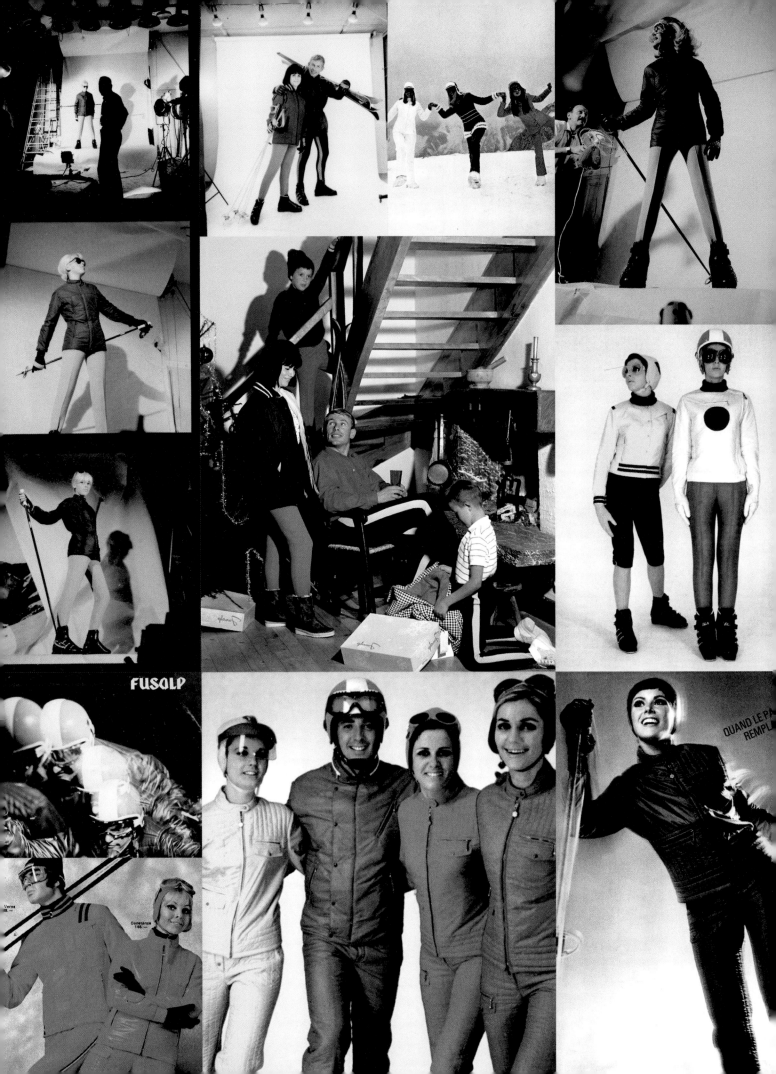

THE PIONEERS OF STIRRUP SKI PANTS

This was also the period that saw advertising take off as never before. Driven by its booming economy, France fairly buzzed with cultural activity and new marketing ideas. These and the advent of the leisure society spawned a whole new style of brand promotion that gave visual identity to the newly born Fusalp. It was then, as traditional image-based advertising stepped aside in favor of new forms of communication, that the brand acquired its reputation for sidestepping the rules and embracing less conventional types of advertising. Its other characteristic is a truculent preference for ads that underscore their homemade origins-most of its "models" are salaried workers in the Fusalp supply chain, among them sales manager Claude Lavorel and his aunt, who feature in a surrealist concoction straight out of *Twin Peaks*.

This homespun approach to its brand strategy is a constant feature in the history of Fusalp, whose image, like its clothes, is unmistakably identifiable.

> **"Fusalp was almost certainly the prime mover behind winter sports dress codes for decades–our new collections were always eagerly awaited."**

JOEL GLEYZE
FUSALP CEO, 1984-2007,
PRESIDENT, 2006-2013

Previous two pages:
The 1960s: Fusalp eschews traditional advertising in favor of an alternative message.

Right:
Fusalp is also about cultivating elegance, in town and mountain alike (1969).

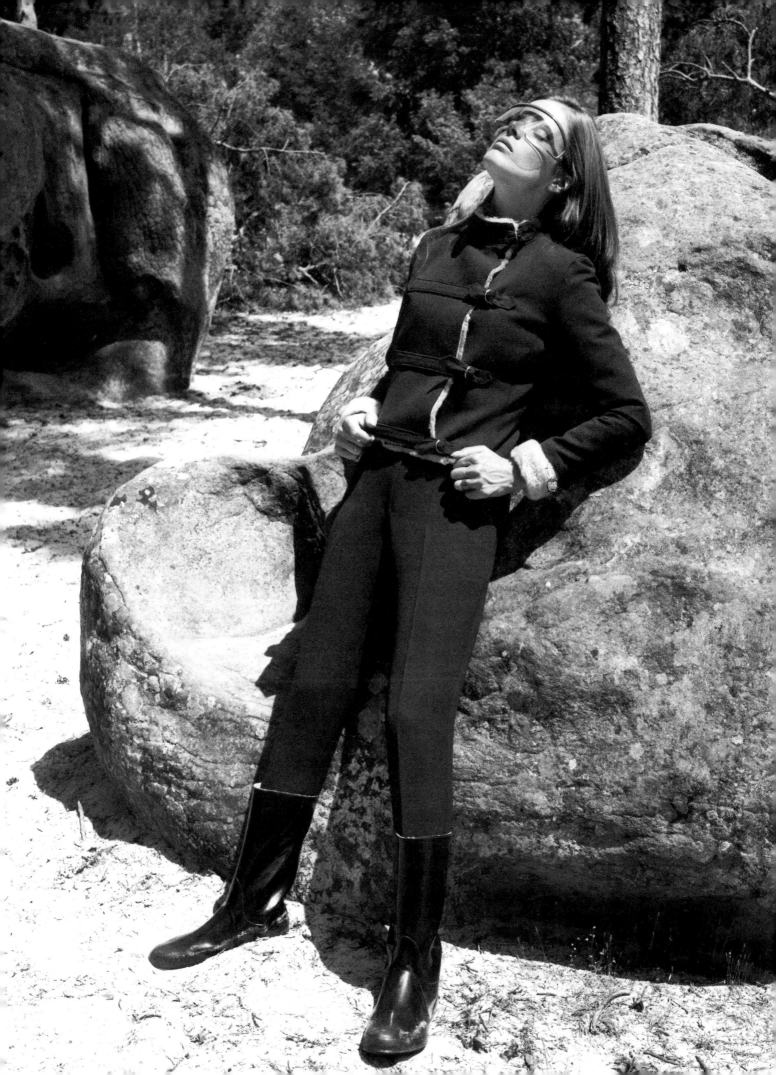

Left:

Ingrid Buchner, Fusalp stylist from 1965 to 1984, wears her latest creations in 1967.

Right:

The Fusalp signature loud and clear: stretch material, quilting, the fit and primary colors (1977).

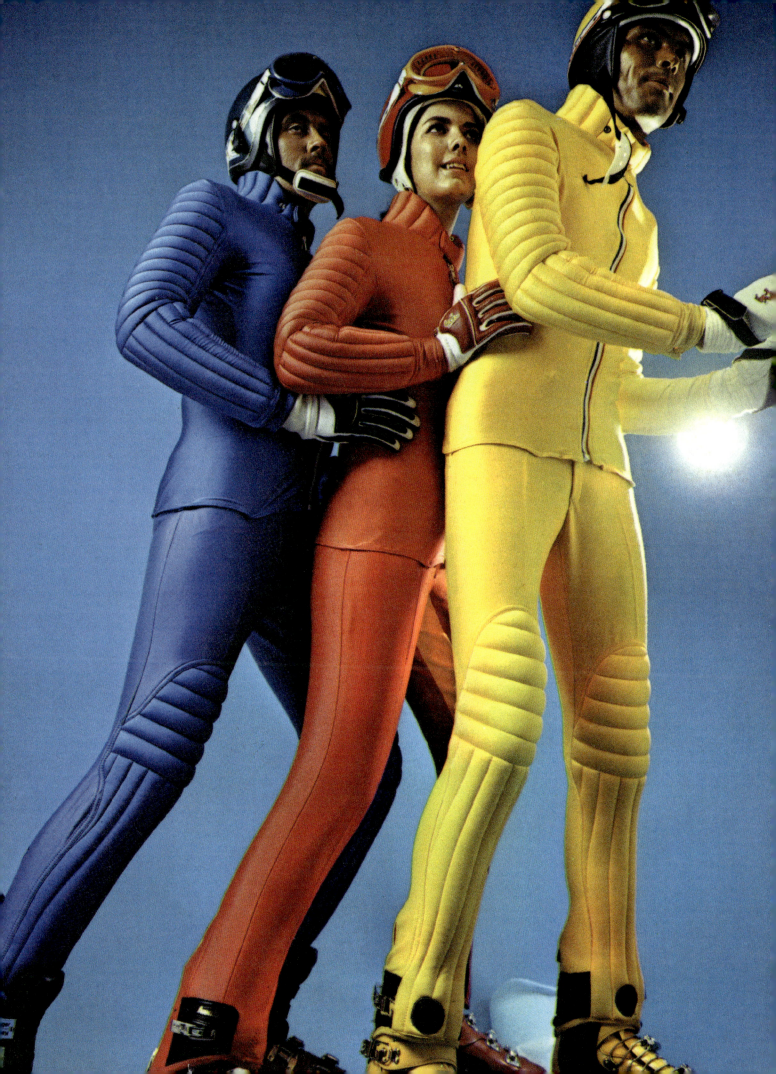

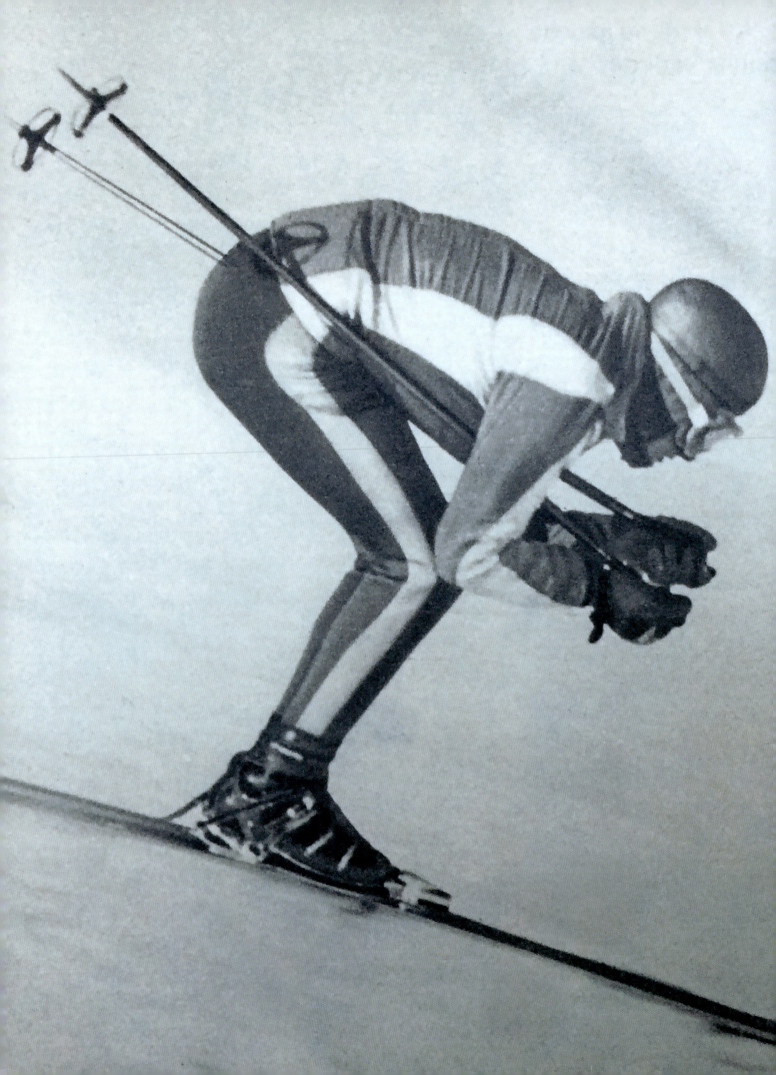

A ski brand endorsed by champions

'My favorite sports person is Marielle Goitschel.'

CHARLES DE GAULLE
PRESIDENT OF FRANCE, 1959-1969

Previous page:

Fusalp accompanies French champions as they spread their wings.

Right:

Christine Goitschel (left) and Marielle Goitschel at the Olympic Games in Innsbruck, Austria, 1964.

A SKI BRAND ENDORSED BY CHAMPIONS

When Marielle Goitschel won the giant Slalom in Innsbruck, Austria, she said on television that it was a win for France and for General de Gaulle. Today she adds, thinking of Fusalp: *"Perhaps it's the Gaullist in me, but a flagship French product created by two men from Savoy is a source of great pride …."*

Performance is written into Fusalp's DNA. Champion performance was the making of the brand and the legend behind it, spurred by Olympic achievements. Fusalp's technical expertise is directly linked to the string of unbroken world victories enjoyed by French ski teams in the early 1960s. Marielle Goitschel, nine-time gold medalist at the Winter Olympics and World Championships, remembers the 1960s as a period of intense innovation for the brand: "It moves me to think that France was elevated to glory by the technical prowess of a French brand – an enterprise whose ever more ingenious use of quality materials was way ahead of its time."

The "two men from Savoy" behind this adventure worked closely with the athletes who set off to conquer the slopes–a place where sartorial precision is measured in hundredths of a second, and gold medals. It started with the female Olympians, Annie Famose Michèle Jacot, Fabienne Serrat and sisters Marielle and Christine Goitschel, followed by Christine Rossi, who set new records and won more medals than ever before. Their male counterparts included Jean Vuarnet, François Bonlieu, Jean-Claude Killy, Guy Périllat, Jean-Noël Augert and the very genial Léo Lacroix, who like French road racer Raymond Poulidor, holds a special place in the French imagination. Winner of two silver medals at the Winter Olympics plus a third at the 1966 Portillo World Championships in Chile, Léo Lacroix laughingly describes himself as the most silvered man in France.

It was Léo Lacroix who inspired the creation of the now famous ski suit in which the French shone at the Portillo World Championships. *"I went to see Fusalp because they had an excellent reputation and were among a pool of manufacturers who had joined forces in 1960."* At Léo's request, Georges Ribola devised a new downhill ski suit that drew heavily on technical experimentation. It was also at Léo's insistence that he, Veyrat and Ribola paid a visit to a glass works to test the

Fusalp, chosen partner of the greatest Alpine ski champions (1970). From left to right, Bernard Orcel, Jean-Luc Pinel, Alain Penz, Roger Rossat-Mignod, Patrick Russel.

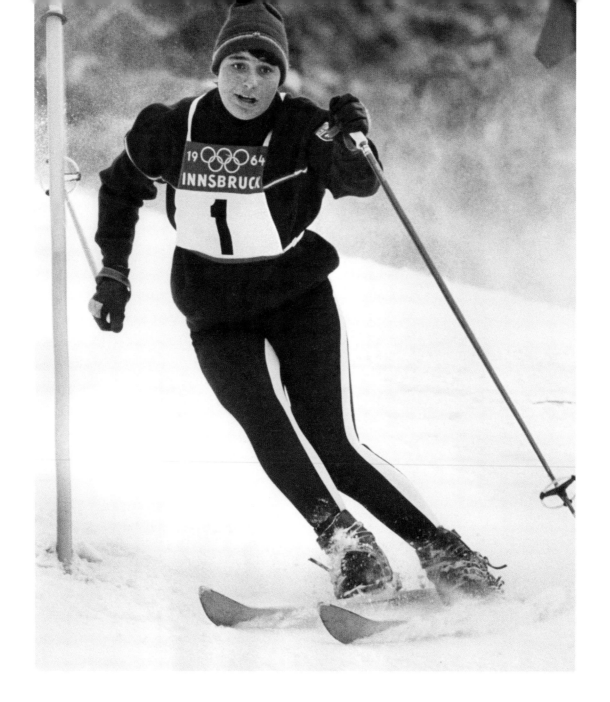

"It was a win for France and for General de Gaulle. Perhaps it's the Gaullist in me, but a flagship French product created by two men from Savoy is a source of great pride ..."

MARIELLE GOITSCHEL
OLYMPIC AND WORLD CHAMPION
FUSALP AMBASSADOR

> "We looked terrific in those ski suits–like spacemen bound for the moon."

LÉO LACROIX
OLYMPIC AND WORLD DOWNHILL SILVER MEDALIST

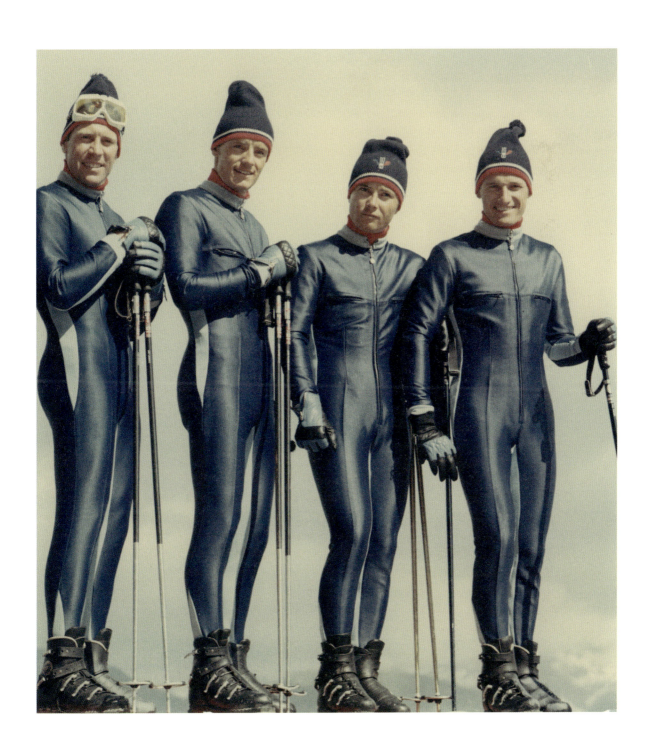

A SKI BRAND ENDORSED BY CHAMPIONS

fabrics for airtightness. "Something had to be done because what with floppy anoraks and floppy bib numbers we were literally being pulled backward." It was vital to develop new ways of finishing the seams on ski suits. And so it was that within three months, the one-piece ski suit had arrived – or as Léo puts it, the ski suit that broke the mold. Production work commenced in the summer and was crowned with success in Portillo in the heart of the Chilean Andes, winning a historic victory for the French and no less than sixteen medals.

Not only was France's technical expertise the envy of the other competing countries but as Marielle Goitschel recalls: "We stole the show at the opening ceremony. The ski suit was such a sensation that Paris Match magazine gave it a two-page spread." Almost as an afterthought she adds, "It's quite simple really: after Innsbruck, where my sister and I won hands down, the girls on the French team won every prize at Portillo!"

For Léo Lacroix:"One morning in Portillo, we arrive for the start of the race and the Austrian favorite Karl Schranz is wearing this all-black ski suit. It looks incredible, particularly since he's cut the straps off his bib number and sewn the bib directly onto the suit. Anyway, at the top, we always did some stretches before the off and all of a sudden Schranz' ski suit rips! Just like that, before the race has even started. For us, that counted as a first small victory for the Fusalp ski suit."

Fusalp has a long history of working hand in hand with athletes, spurring them to success on the slopes thanks to a seamless blend of design and technology that starts with teamwork. That iconic 'Léo' ski suit has seen multiple iterations since its conception in 1966, constantly evolving to keep pace with changing trends but always geared toward technical excellence. On the slopes and on the streets, it remains a source of inspiration for people wherever they come from.

Previous two pages:
Left:
Marielle Goitschel carving turns on the downhill at the Innsbruck Winter Olympics, 1964.

Right:
The French ski team champions, in 1966, all wearing "Leo" suits. From left to right, Léo Lacroix, Jean-Claude Killy, Jules Melquiond and Guy Périllat.

Right:
Christine Rossi in acrobatic action at the start of the 1980s.

❛ **Fusalp wasn't entirely focused on Alpine skiing. It also had a contract with what was known in the 1980s as the "artistic skiing and ski acrobatics" section of the French Ski Federation. I captured my first Junior world championships in March 1981, winning the combination and the ski jumping and ballet events, and placed second in the moguls. I was European champion in ski ballet for 10 years, winner of the world cup twice, one-time world champion, and also won a gold medal at the winter Olympics.** ❜

CHRISTINE ROSSI
WINNER OF 26 GOLD MEDALS IN THE PERIOD 1981-1988

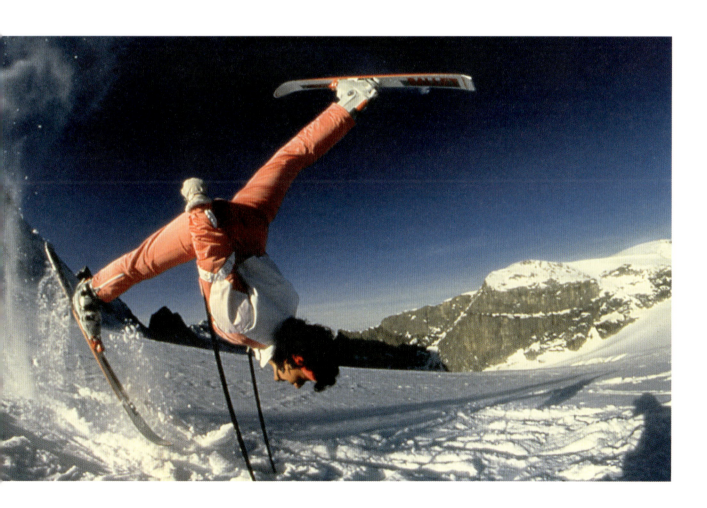

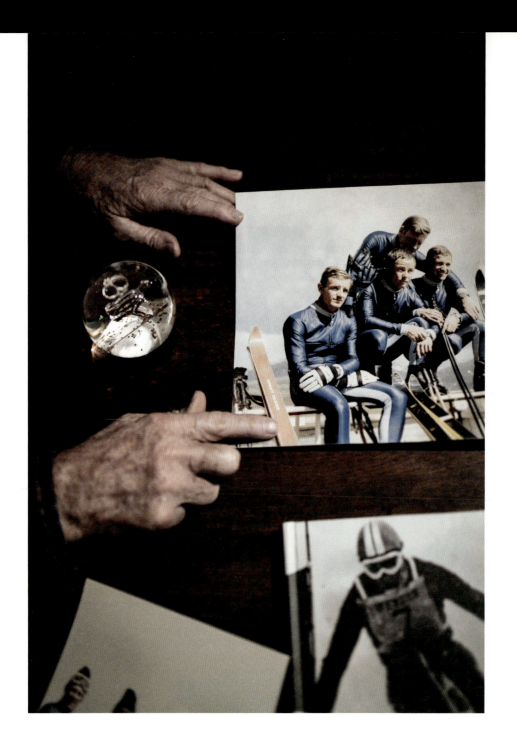

❝ I went to see Fusalp because they had an excellent reputation and were among a pool of manufacturers who had joined forces in 1960. ❞

LÉO LACROIX
*OLYMPIC AND WORLD DOWNHILL
SILVER MEDALIST*

British ski racer Charlie Raposo in the Fusalp racing suit, September 2021, Saas-Fee (Switzerland).

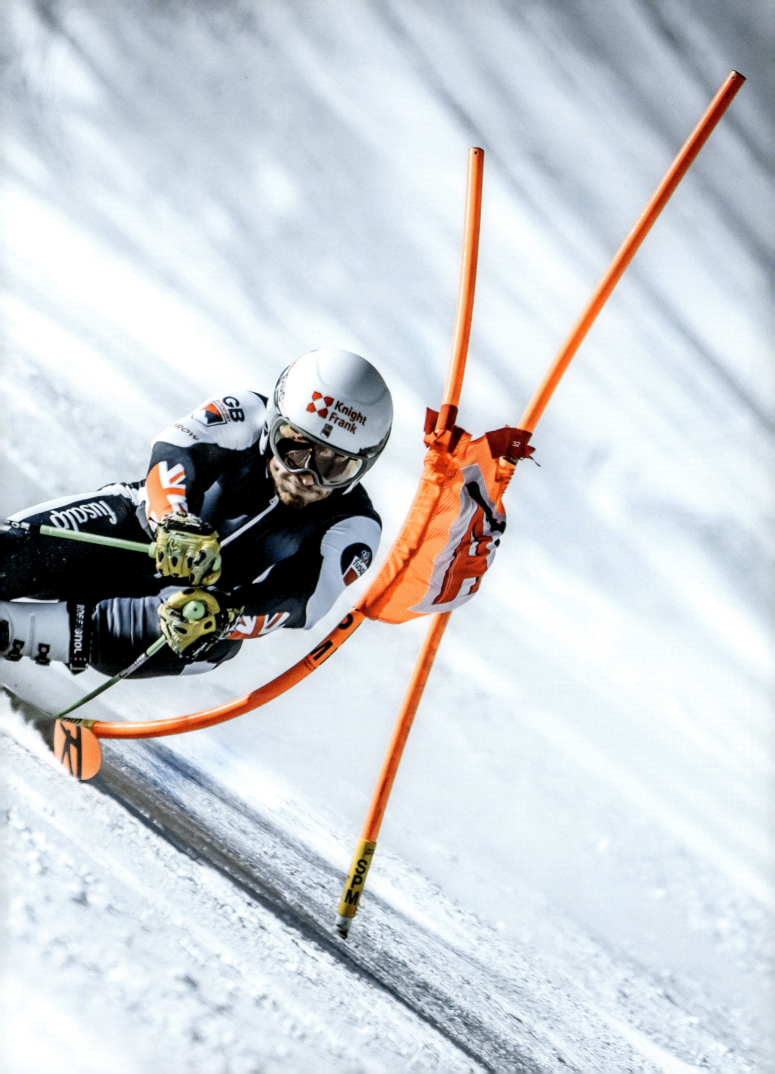

❝ **The truth is that this was the first time we'd had supersonic ski suits, which also explains how we came to leave our mark on skiing. Brand new shape, brand new materials. We would regularly drop in on the tailors in Annecy because Fusalp were like family**❞

ANNIE FAMOSE
WORLD CHAMPION AND OLYMPIC SILVER MEDALIST, SLALOM DISCIPLINE

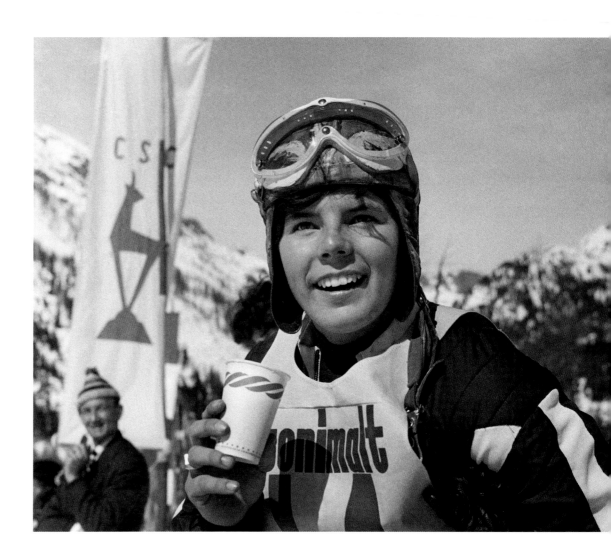

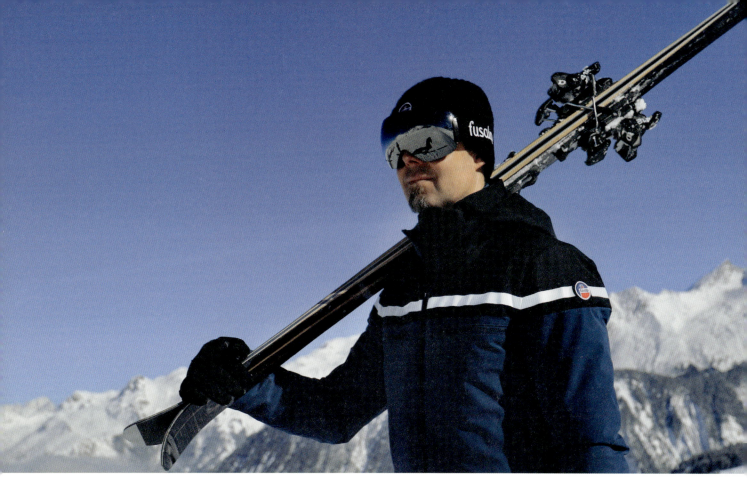

❛I was born in a small ski resort. All the children in my village skied. All you ever did in winter was ski. I used to dream about this racer from our village who'd made it onto the French team. Some kids dream of becoming firemen, policemen or footballers. Me, I dreamed of being a skier. There was skiing on the national TV channel every Saturday and I used to rush out of school so as not to miss it. My childhood heroes all skied.❜

ANTOINE DÉNÉRIAZ
TURIN OLYMPICS DOWNHILL CHAMPION
FUSALP AMBASSADOR

A SKI BRAND ENDORSED BY CHAMPIONS

‘That's what moved us the most: the fact that it still looked so modern.’

ALEXANDRE FAUVET
GENERAL MANAGER SINCE 2014

Previous pages:

Left:
Annie Famose in Chamonix, 9 March 1963, winner of the Kandahar downhill.

Right:
Antoine Dénériaz, Olympic downhill champion in Turin in 2006, and a Fusalp ambassador.

Right:
A brand icon: the "Leo" downhill suit, designed by Fusalp in 1966 especially for Léo Lacroix.

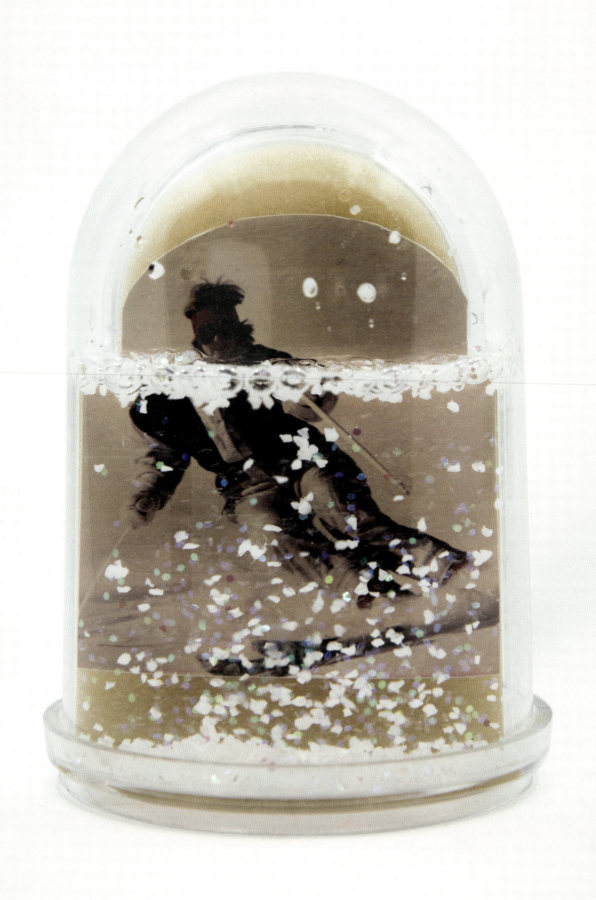

A decade of daring technique and bold aesthetics

1968 - 1980

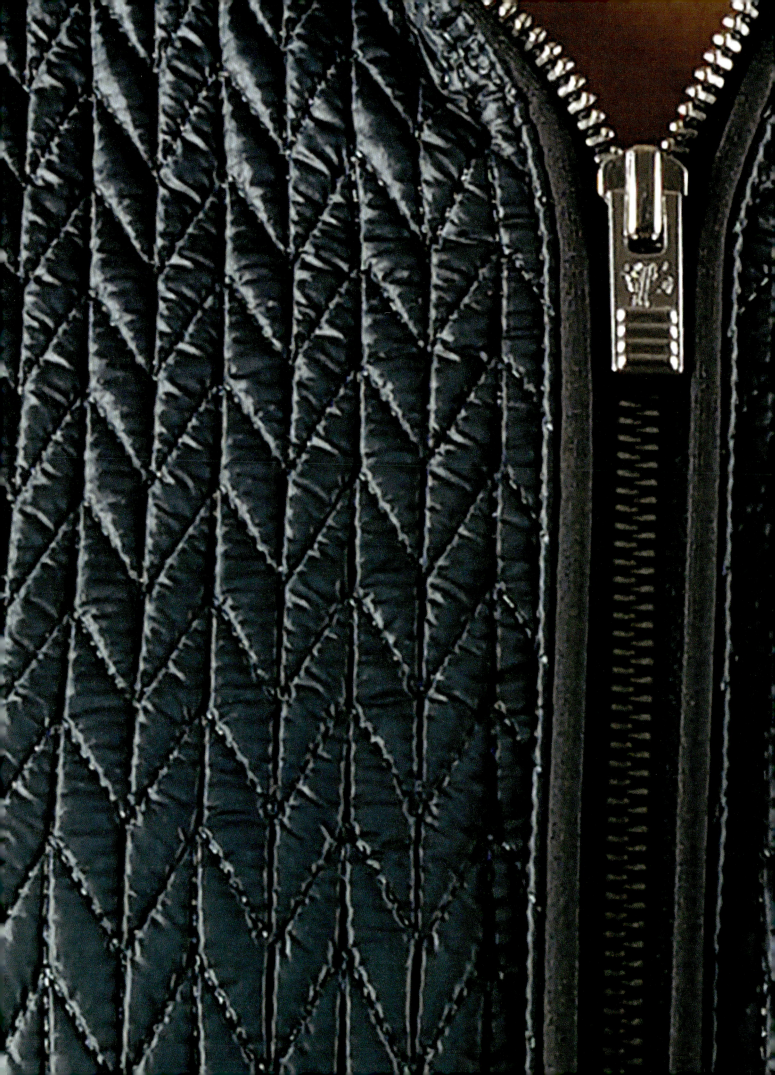

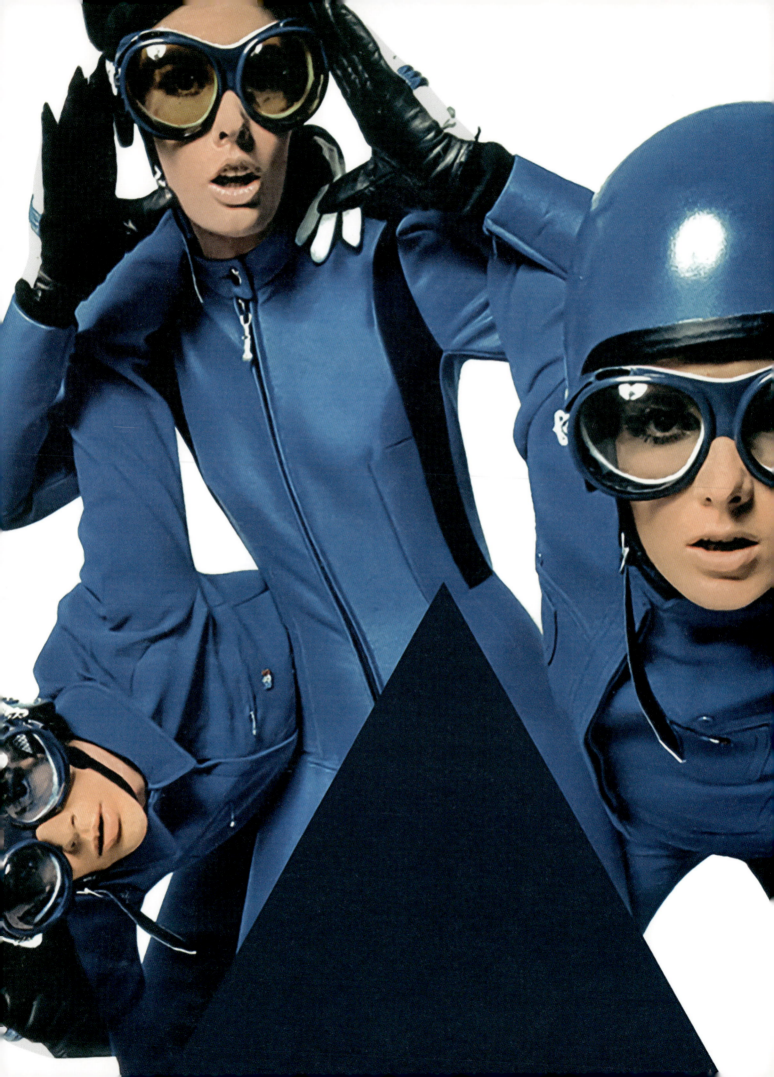

A timeless brand with a visionary style

A TIMELESS BRAND WITH A VISIONARY STYLE

In the 1970s, style stood at the crossroads of innovation. Increased productivity introduced a golden age for the brand, together with burgeoning demand for ready-to-wear that led to a boom in the textile industry. To exist at all in the tumultuous seventies, a business needed to stand out and that meant building a strong brand identity. Fusalp responded with a bold revamp of its collections, not least thanks to the orchestrations of German stylist, Ingrid Buchner, who conceived, designed and created a whole new wardrobe. A look sported by generations of skiers but also embraced by the public at large, whatever the season or place.

Ingrid Buchner, an exceptional fashion stylist

Ingrid Buchner was 20 when she left for Haute Savoie to work as an au pair and to learn French. Ultimately she fell in love and settled in Annecy. She met Georges Ribola when she was looking for a sewing job: "I happened to meet Ribola when I first showed up at Fusalp. He wasn't looking to hire but took me on anyway. I can't remember what my job title was but they gave me an office with a table and chair. For the first few months I had no idea what to do so I sketched out some winter sports designs of my own. Ribola hadn't explained anything to me at this point. He did everything himself, probably thinking 'Oh, she's drawing, that will keep her busy.' And so it continued, me drawing away in my own corner, until the day Ribola walked into my office, picked up my sketches and showed them to the designer, a certain Monsieur Trabujo who believed a woman's place was in the home. He looked at my drawings and asked for some prototypes to be made – shapeless affairs that bore no resemblance whatsoever to what I had drawn. So I asked Ribola if I could have a go. I had trained in Germany where unlike here in France you have to take a course in sewing to qualify as a fashion designer. That meant I could create my own prototypes, which looked nothing like Trabujo's. This was in 1964, the year it all began for me.

"Ribola gave me carte blanche and we developed a close working relationship. When I arrived on the scene, Fuisalp essentially concentrated on ski suits. But in 1968, the year of the Grenoble Winter Olympics, what the French team needed were anoraks–which they

Previous pages:
Autumn-winter collection, 1967-1968.

Right:
It was fashion stylist Ingrid Buchner who laid the basis for Fusalp's bold and technical style signature, establishing the distinctive identity of the brand in the 1960s.

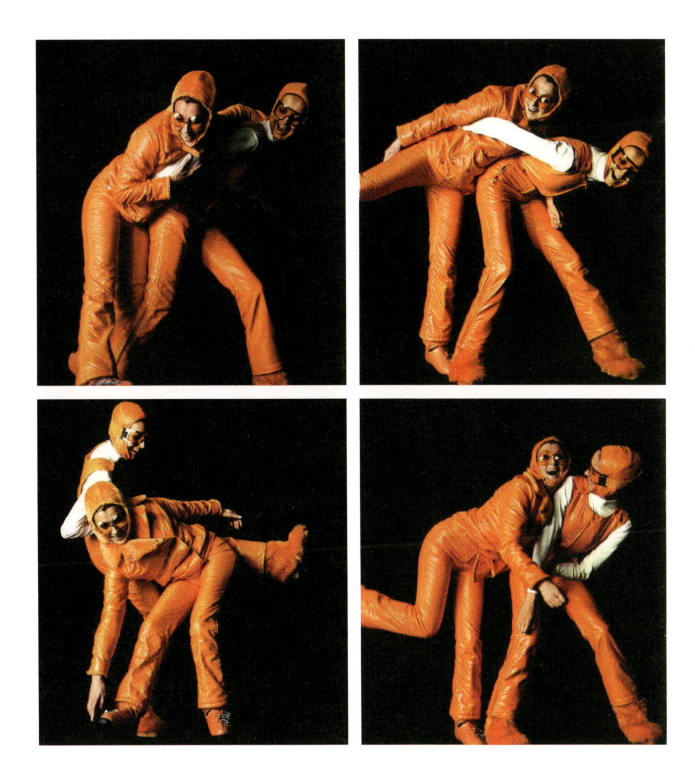

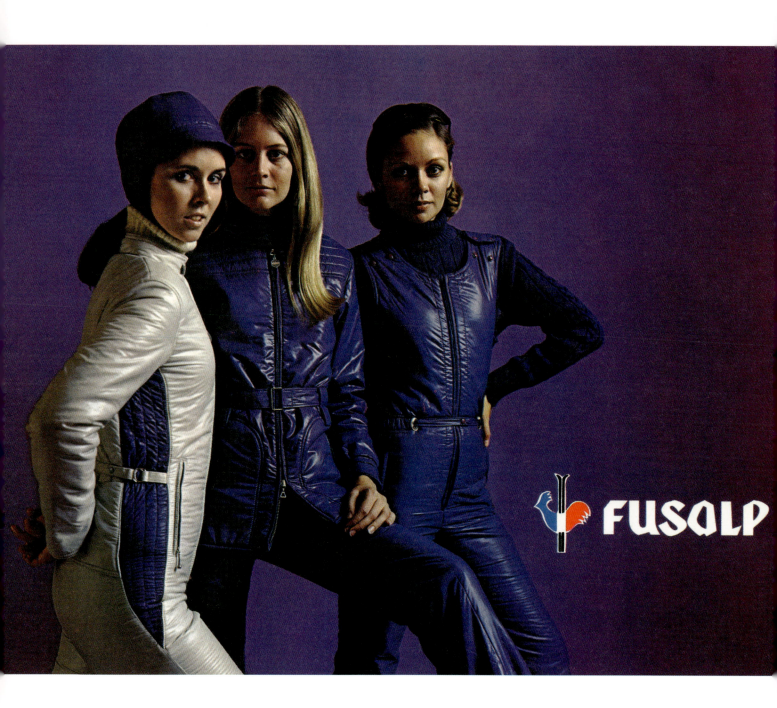

Ingrid Buchner on color:
"It was important to me to be innovative with color, at a time when stylistic trends were heading towards practicality and austerity."
Autumn / Winter collection, 1967-1968.

A TIMELESS BRAND WITH A VISIONARY STYLE

asked me to design. And with that, I went from designing ski suits to designing anoraks and supervising prototype manufacturing. I remember for instance that we used a small Lyon-based supplier for our nylon fabric. It was my idea to ask them to reinforce the nylon as for parachute webbing. That gave us ultra-tough materials–all we had left to do was work on the beauty of the silhouette, the line of the anoraks, so people would want to wear them.

"I have always thought in artistic and technical terms as a whole the while looking for innovations. We were the first brand to bring out over-the-boot ski pants–something completely new that opened up a new direction for Fusalp. After that, it really wasn't hard to come up with outfit ideas for everyday wear. The great thing about those days was that you could be as creative as you liked. Anything was possible. Rather than go with an approach focusing exclusively on skiing, I quickly realized that sports clothes had to work as street wear too. Something else that was completely new. No sooner had I completed one collection than I was already thinking up new ideas for the next one, concentrating on the materials and range of colors available. Being innovative with color was a big thing with me at a time when sensible, austere fashions ruled the day."

> **"The great thing about those days was that you could be as creative as you liked. Anything was possible."**
>
> INGRID BUCHNER
> *FASHION STYLIST FOR FUSALP FROM 1965 TO 1984*

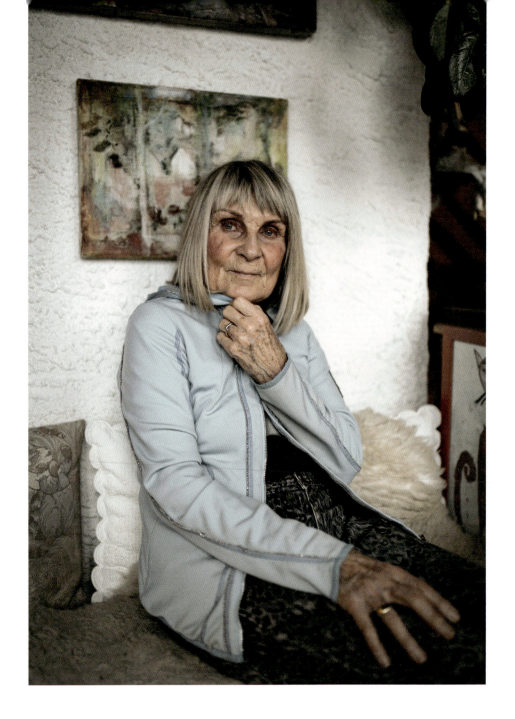

❝I don't draw anymore. When I retired, I told myself I would never pick up a pencil again. To think that I started drawing when I was 16. I must have drawn thousands of pictures❞

INGRID BUCHNER
FASHION STYLIST FOR FUSALP FROM 1965 TO 1984

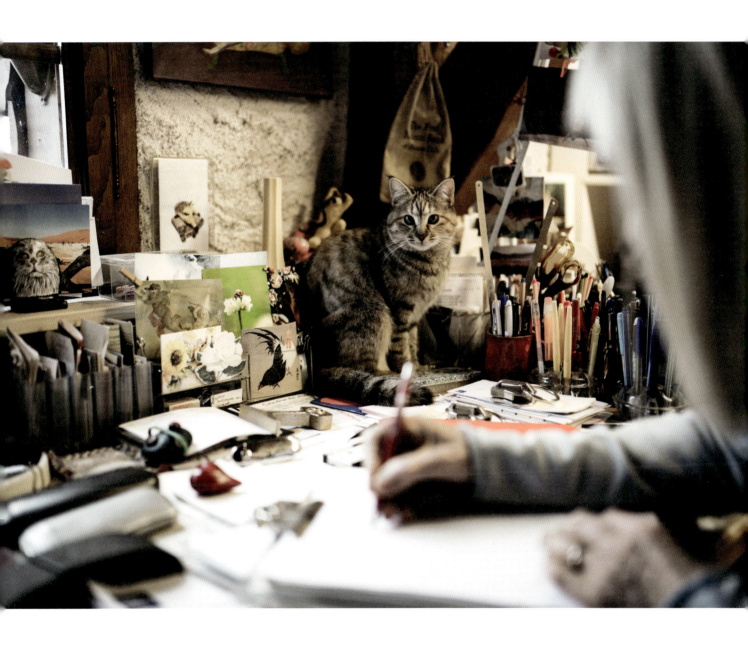

Above and following pages:
A visit to her workshop–a secret garden of threads and bobbins ...

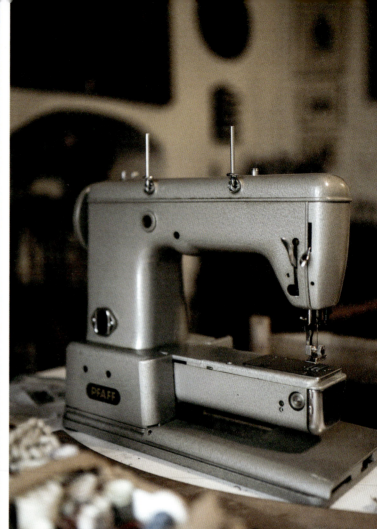
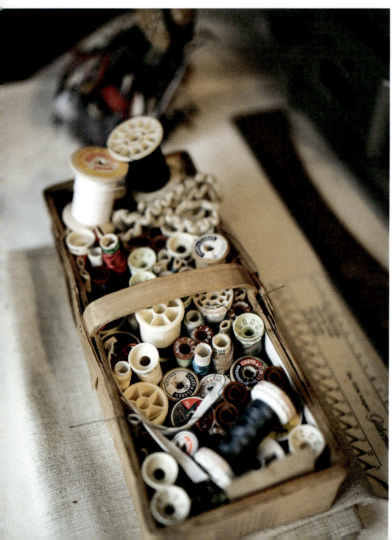

'The fact that there was something so conservative about ready-to-wear fashion gave me and my co-designer Nadine Portigliati lots of scope to play with new shapes. For instance, we launched into making snow skorts with matching padded gaiters. We made the first overalls too... For us it was all about predicting fashion trends ... creating a perfect fusion of function and style. Afterwards I got offered a job with the German company Bogner, the global market leader at the time, but I turned it down. Partly because I had fallen in love with a Frenchman and partly because Fusalp gave me such extraordinary freedom.'

INGRID BUCHNER
FASHION STYLIST FOR FUSALP FROM 1965 TO 1984

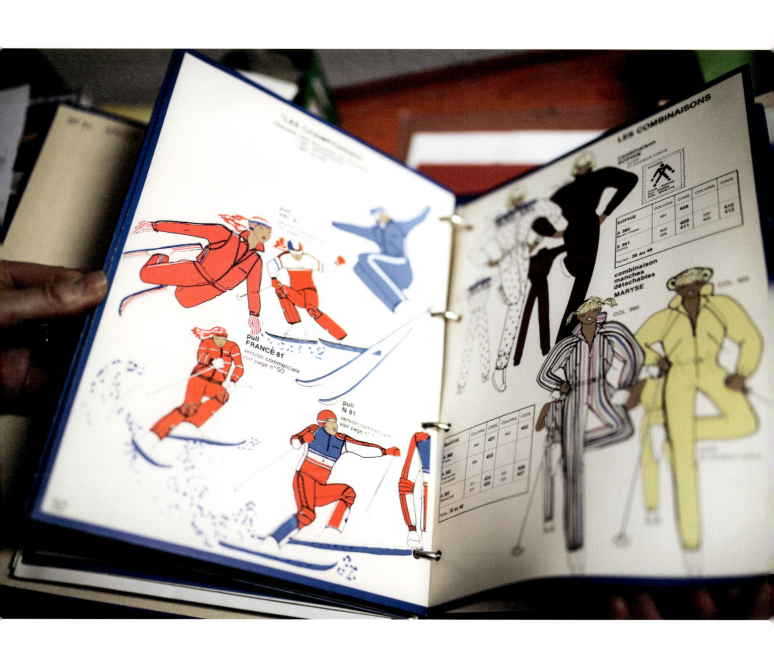

A TIMELESS BRAND WITH A VISIONARY STYLE

Nadine Portigliati worked closely with Ingrid Buchner on a daily basis to help develop new ways of merging aesthetics and technical functionality.

"I would deal with suppliers, draw and, after they sent me on a course to Paris, I would create the odd prototype too. I helped Ingrid with every aspect of the job. I remember not being able to draw and Ingrid thinking it would be a good idea for me to take a drawing course. And just like that, she sent me to Paris! After that I was in charge of materials research and receiving visits from suppliers–they were the ones who taught me the ropes.

"Learning the job from sales reps meant that I got to know all our suppliers. So for 15 years in addition to working in the design office I was also in charge of purchasing. I would help with product development and selection–choosing the fabrics best suited to the product. Later I went back to designing collections and ultimately ended up running the design department. These days let's say I play an advisory role, which means I get to do a bit of everything. I've gone from being the youngest member of staff when I first joined the company to the matriarche of Fusalp today. Looking back, I'm reminded of just how much we achieved working together as a family."

"I quickly realized that sports clothes had to work as street wear too. Something else that was completely new."

NADINE PORTIGLIATI
HEAD OF MATERIALS DEVELOPMENT

Previous pages:
Nadine Portigliati opens the doors to the Annecy workshop, and opens the pages of the Fusalp archives.

Right:
Nadine Portigliati at the Fusalp factory in Annecy, 2021. She started as a model when she was 17, and has stayed with the brand ever since.

Following pages:
The Haute-Savoie mountains, where Fusalp was born.

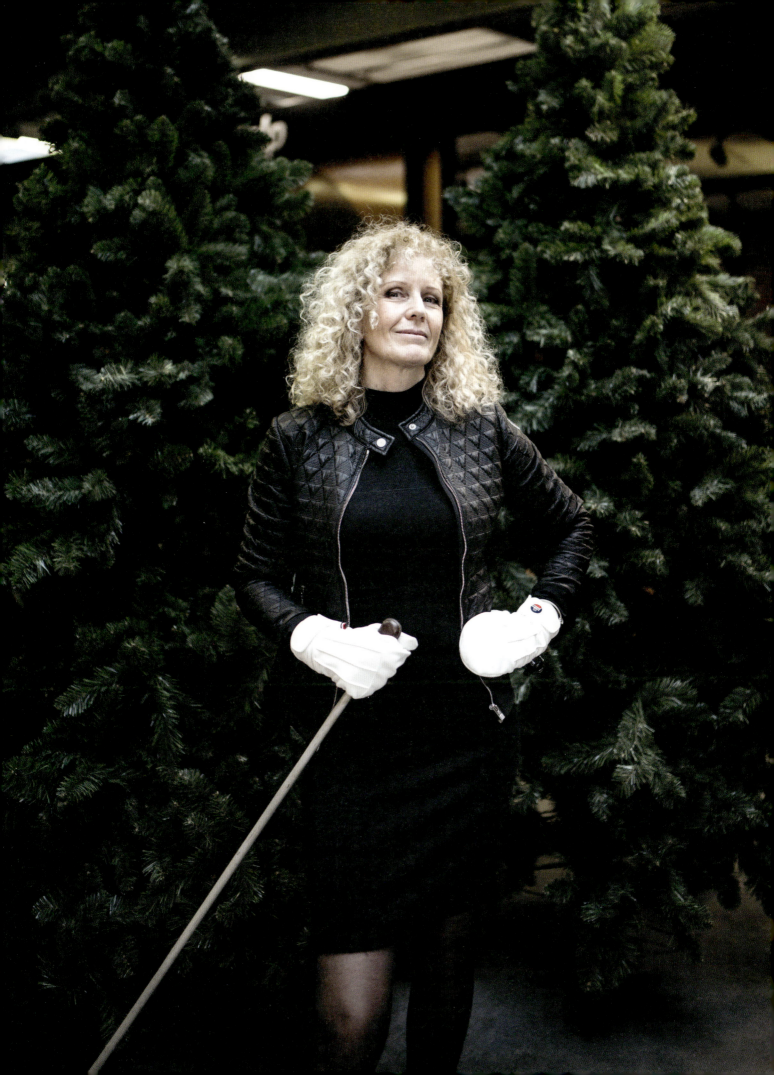

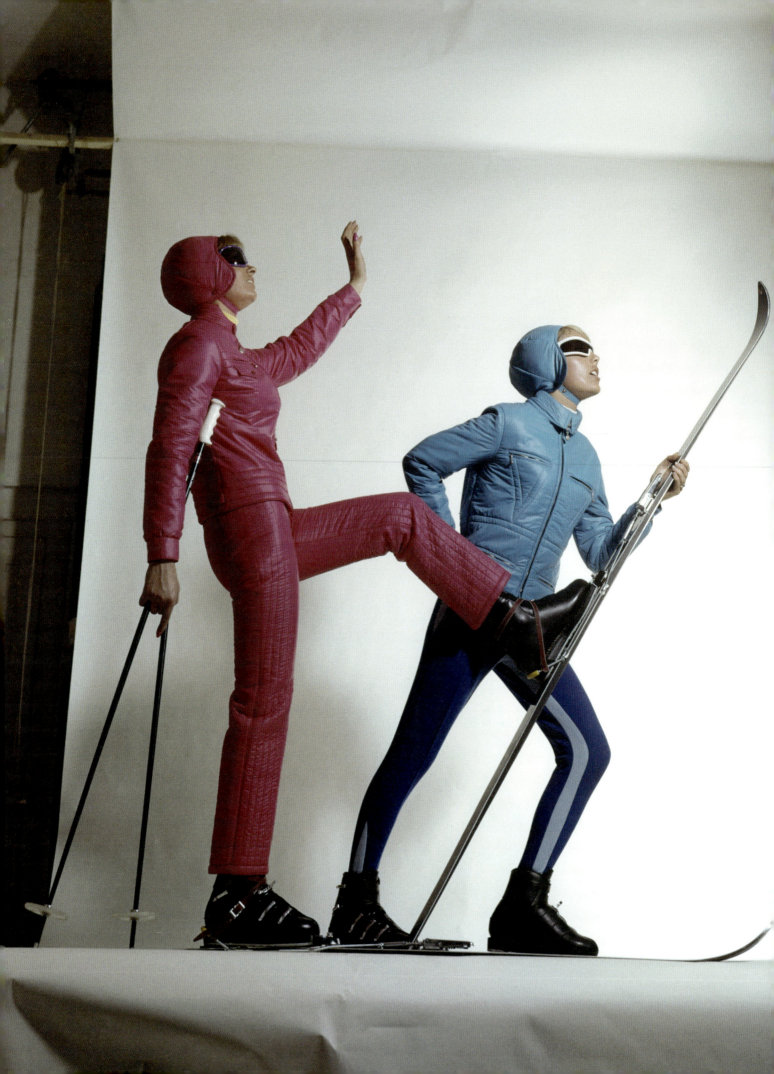

Brand ascent: reaching beyond borders

BRAND ASCENT: REACHING BEYOND BORDERS

n 1970, Fusalp employed 400 people and had an annual output of some 500,000 articles. Its success as a business venture is built on a company culture where technical and aesthetic considerations go hand in hand with promoting teamwork in the workplace. Nadine Portiglio, doyenne of Fusalp, remembers it well:

"What struck me in the seventies was this amazing team spirit and excitement surrounding new collections. Fusalp was a real laboratory for new ideas, new styles, new designs … everyone pulling together to achieve perfection.

"We'd invite sportspeople to come and test the products, point us in the right direction. It was a constant quest to find new fabrics, working closely with manufacturers in the Lyon region and suppliers of fiber to explore new ways of renewing our collections. Everything revolved around technique and elegance, looking to deliver collections so eagerly anticipated that our creations were sold in advance of the regular selling season.

"It has to be said too that Fusalp developed in tandem with a rapidly evolving textile sector, which forced us to adapt and invent ever-higher performance clothing. Ingrid Buchner's first cold weather pants are a good example. It was her idea to line them with wadding, held in place by quilting stitches. That counted as a mini revolution in 1966. We mainly worked on the air permeability of fabrics, their breathability in other words. First came induction, then came membranes … But we also wanted more water-resistant fabrics, so we tested the rate of droplet flow. To begin with, we got 300 Schmerber, the standard unit for measuring waterproofness, which was considered ultra-performance. From there, we went to 1,000 then 10,000 and today we're at 40,000 Schmerber for some fabrics. As part of our research on waterproofing, we also worked on increasing the tensile strength of fabrics. We developed threads that were more resistant to abrasion and tearing. The first ultra-light nylon prototypes were revised to minimize slippage and the first competition pants were reinforced with rubber flanges that we designed with the help of tire manufacturers. Hutchinson for instance was asked to provide us with semi-circular flanges that we inserted inside the pant linings to protect competitors from bruising when they hit the gates. Later we worked with a boat

Previous page:
Performance and elegance perfectly poised for easy movement, Fusalp photo shoot in 1966.

Right:
Photo shoot of the fitting of the "Solaize," the first Fusalp anorak, 1962.

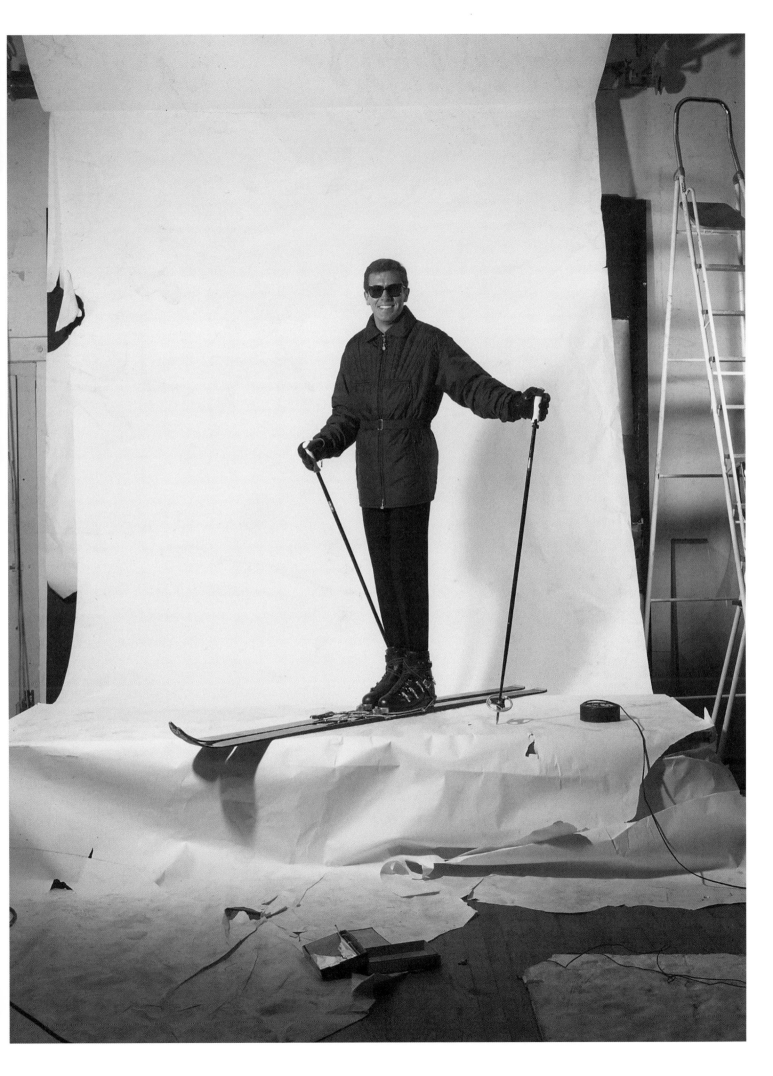

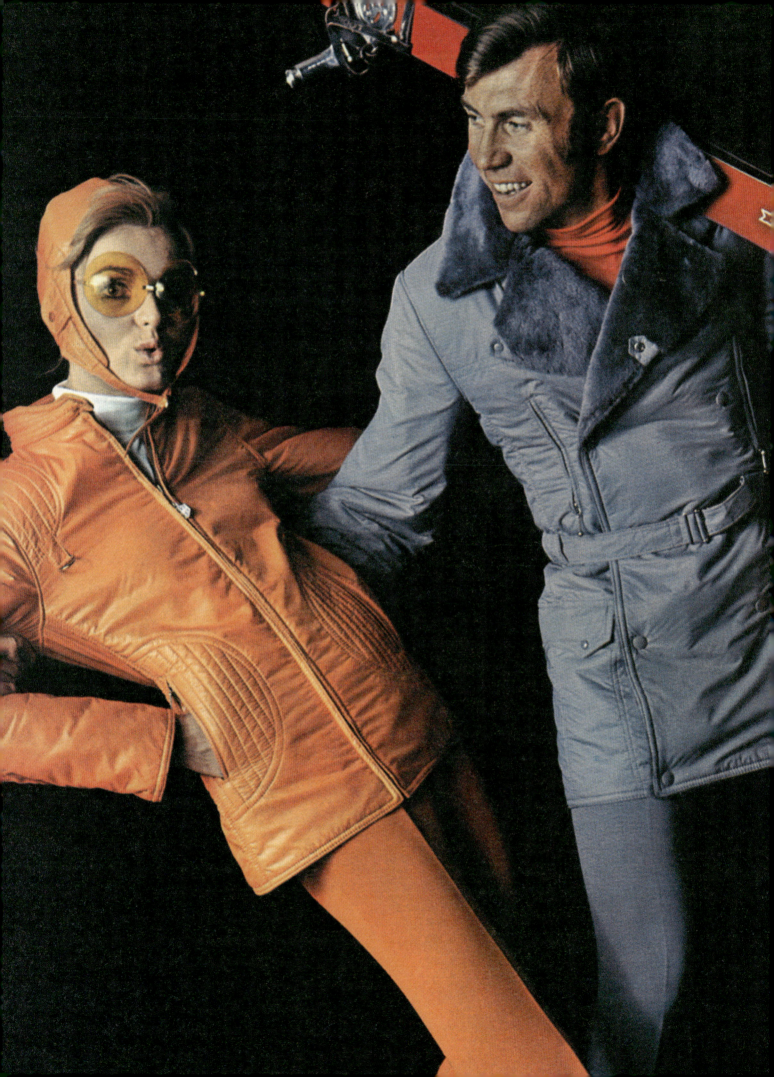

BRAND ASCENT: REACHING BEYOND BORDERS

manufacturer on flanges made from the foam you find inside boat hulls. It was very light and shockproof–we used it for all of our pants and pullovers ...”

“The new collections were an instant hit in countries outside France. The US, Asia–markets that were always keen to embrace innovative fashions. They appealed to Italian sensibilities too. The French on the other hand tended to shy away from change and had to be broken in gently, collection by collection. We only took the plunge when we felt people here were well and truly ready for a radical new look.”

The 1960s saw Fusalp pioneer a new dress code that took shape in the 1970s, not least thanks to soaring demand from overseas markets. The Sapporo 1972 Winter Olympics gave the brand its first foothold in Asia, most notably in Japan where Fusalp enjoys a long-standing presence.

By the close of the decade, Fusalp was employing more than 1200 people and operating production facilities in the departments of Savoie and Haute Savoie. It was boom time for ski brands, with the likes of Montant, Moncler, Rossignol and Salomon aiming to corner the market through well-honed export strategies that revolved around trade fairs: the Grenoble Trade Show in France, for instance, and the Internationale Fachmesse für Sportartikel und Sportmode, ISPO for short, the world's largest trade fair for sporting goods, held in Munich every year since 1970. Events like these bring together all members of the industry, global players in sportswear and ski resort operators alike, shaping the trends that define the fashion agenda. Fusalp has always heeded those trends over the years, launching collections that varied with the season but gave it a strong presence in Europe and beyond, from the USA to Asia and the Middle East.

Raymond Barra was a key figure in Fusalp's international strategy: a man who rode the waves of championship victories delivered by Killy, Lacroix and Goitschel–to mention just a few–but mainly a man of daring who saw how to leverage long-lasting international partnerships. “In 1967, I got a call from a headhunter summoning me to Paris for two days. Fusalp wanted to recruit me for the upcoming Grenoble 1968 Olympics–the perfect springboard for exports at a time when hardly

A real laboratory for new ideas: from 1969 onward Fusalp style shows through in unique collections combining sport-chic with technical performance.

BRAND ASCENT: REACHING BEYOND BORDERS

anyone had a foothold in Europe or the USA. So I traveled 500 miles from my home in northern France to resettle in the Haute Savoie where Fusalp asked me to focus on exports to German-speaking countries. Being a German specialist and Germanophile, the arrangement worked well from the start.

"Our target was to sell the Germans 10,000 articles–and we sold the lot. In the process, we earned a reputation for product expertise that gave us a strong brand presence at the Grenoble Olympics.

"I spent several months in Germany, barging into sportswear stores, with a stylish woman's anorak under one arm and stirrup ski-pants under the other, insisting on seeing the manager, which they'd say was impossible without an appointment, but me being a Frenchman who speaks perfect German, the manager would see me anyway out of curiosity–and end up buying 10 anoraks and 10 stirrup ski-pants just to make me happy.

"We also forged partnerships with Asian countries, particularly Japan; also with Australia because, strange as it may seem, you can go skiing in Australia too. Believe it or not, I actually made friends with the Shah of Iran's ski instructor. The situation was a bit complicated in Iran under the Shah because it was strictly forbidden to import sportswear. Iran could only sell its own goods. So I hit on a solution with my ski-instructor friend: I used to dispatch my boxes from Grenoble via Pomagalski, which built ski-lifts in Iran, and put my boxes inside their wooden crates to get them through customs. One day, I paid a visit to a client in Saint Moritz and fell upon a bodyguard who stared at me aghast; and who should I see behind him but the Shah of Iran's wife coming out of a room where she was trying on Fusalp ski suits ...

"I stayed with Fusalp several years. Success came quickly and we limited the supply of products to increase demand–turn them into something rare and precious. We always kept our word, always delivered the goods. That's how we expanded into new markets.

"By around 1975, we were working with the USA where I'd set up a whole export system. Every year I'd spend several weeks going around our export partners in Boston, Las Vegas, Chicago and other places.

Right:

As Fusalp makes inroads in international markets, the brand launches its children's collections under the name Junalp. Here, the 1967-1968 autumn-winter collection

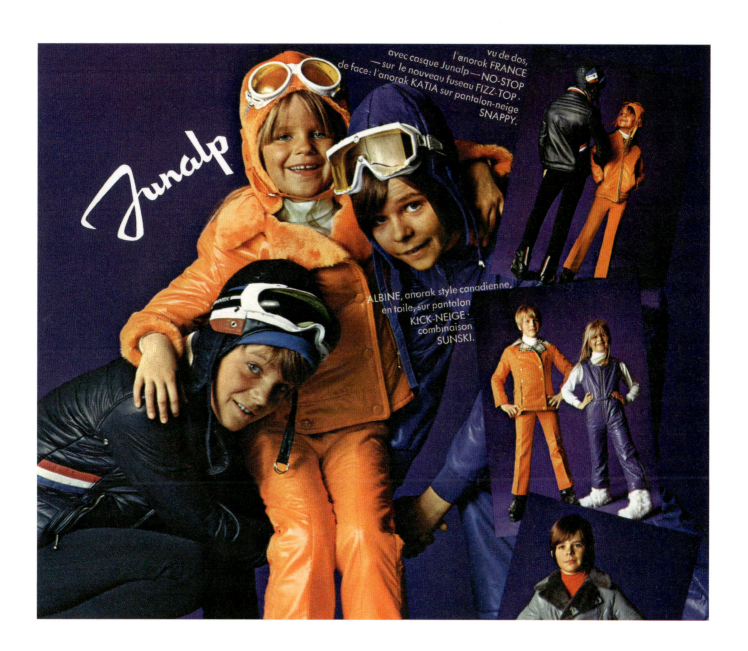

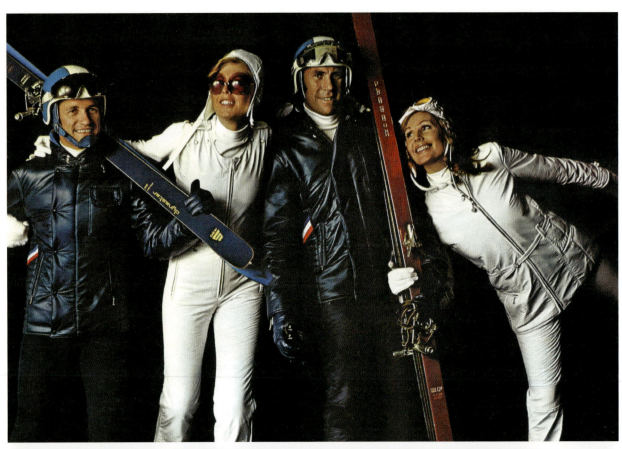

BRAND ASCENT: REACHING BEYOND BORDERS

I'd just turned 30, spoke fluent French, English, German and Italian–so fluently that people in Berlin, Rome, Stockholm and London used to contact me directly. The 1970s were our heyday.

"Despite the crisis that followed, working with Fusalp was an incredible experience I will never forget–a terrific success by any standard."

> **"Success came quickly and we limited the supply of products to increase demand–turn them into something rare and precious. We always kept our word, always delivered the goods. That's how we expanded into new markets."**
>
> RAYMOND BARRA
> *FUSALP EXPORT MANAGER*

Left:
The years 1970-1980 were a decade of bold innovation–a time of outstanding success for Fusalp that boasted outlets now in Europe, Asia and the United States.

Following pages:
Visuals for the 1970-1971 autumn-winter collection.

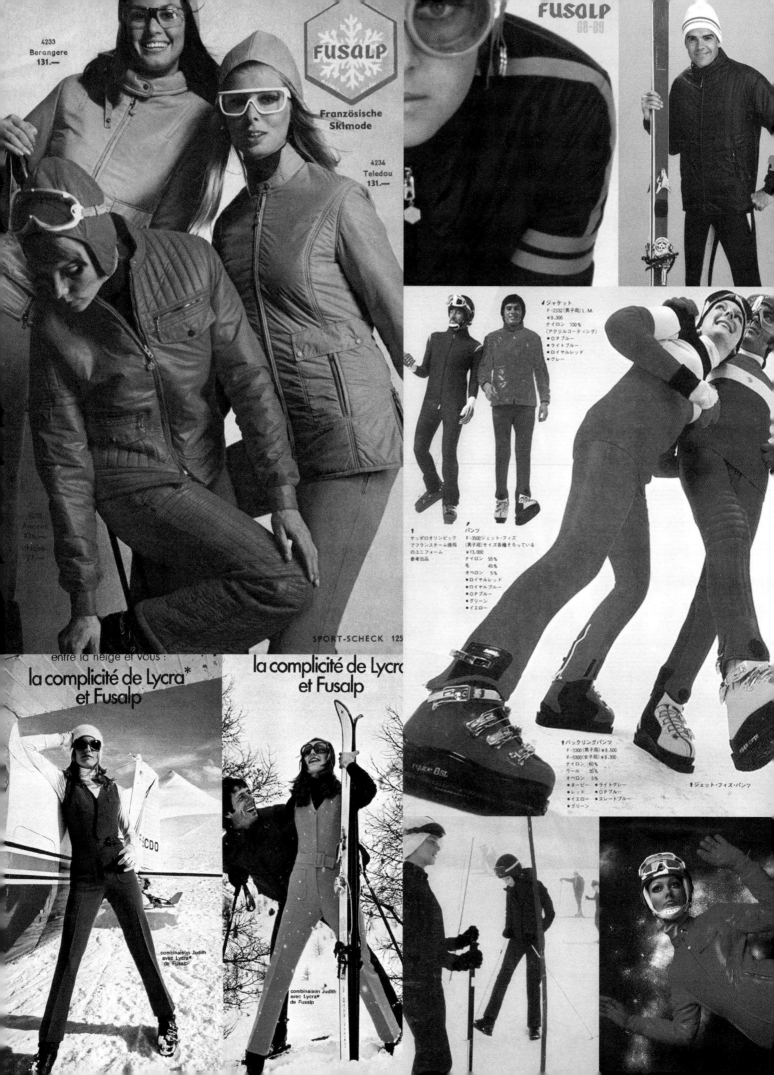

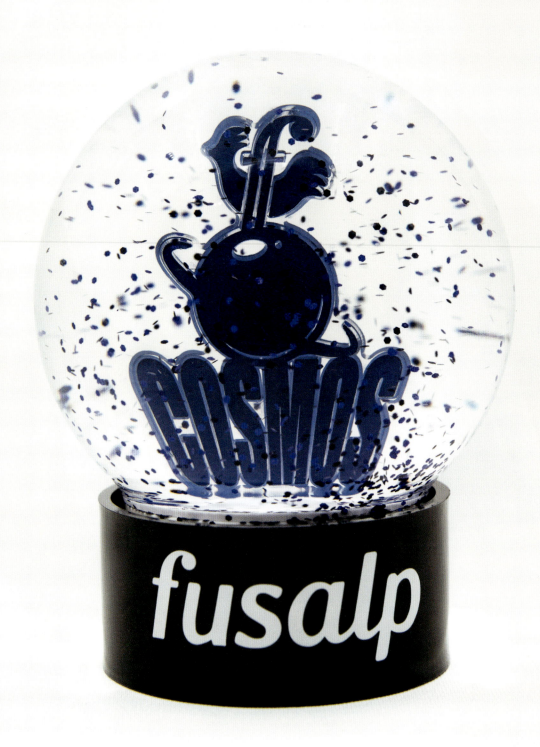

Fusalp confronts the challenges facing the global textile industry

1980 - 2014

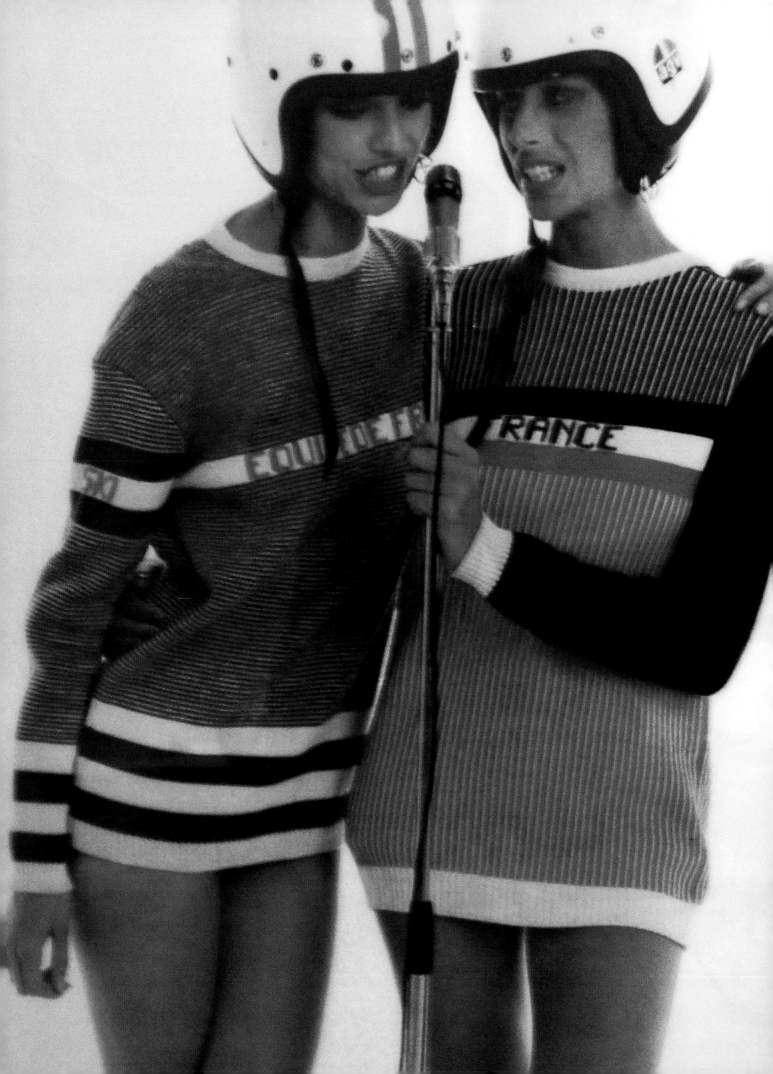

A wave
of innovation

A WAVE OF INNOVATION

By the mid 'seventies, Fusalp was a healthy business operating out of six production sites. Then came signs of a looming recession that prompted Messrs. Veyrat and Ribola to bring their involvement to a close. It was the end of an era for the company that had been their lifelong passion and made their country proud.

In 1976, Fusalp was acquired by dashing French captain of industry, Edouard-Jean, 3rd Baron Empain. Heir to the Empain-Schneider Empire, he is better known for his abduction in 1978–what became known as the Baron Empain affair. He was held hostage for 63 days, starved, beaten, chained in darkness and had one of his fingers cut off. Meanwhile friends and shareholders argued bitterly about whether or not to pay the ransom.

Joining forces with the Empain Group brought a change in strategy for Fusalp, which henceforth had to comply with the practices already in place within the group, whose investors included General Electric and Renault. Empain also acquired the Montant and Dynamic brands, meanwhile ramping up the pace of production in its frantic efforts to achieve ever-greater output. The result was a dumbing down of products at the expense of the creativity at the heart of Fusalp.

In the words of Ingrid Buchner: "*When Baron Empain acquired Fusalp, the people he appointed to run the company came from financial services and other subsidiaries. They had no experience in textiles, even less in the development of collections. So for the first few years Fusalp lived off its reputation, relying on its flagship products to keep it from going under.*"

Eventually however, the Empain family's misguided strategies got the better of Fusalp. In 1982 the company passed into the hands of French financial group, Le Refuge, which promised to recapitalize the business.

All of this must be seen in the context of the political and economic unrest triggered by the 1980s oil crash and the first waves of business relocation, which in turn led to unprecedented job losses. Fusalp was one of the hardest-hit companies. Production sites employing largely

Previous pages:
Shadow of the chairlifts at the Tignes lift station.

Fusalp champions in full song!.

Right:
Crisis on the way in the 1980s. In difficult economic circumstances, Fusalp demonstrates its commercial agility, playing on its reputation and leading products to survive.

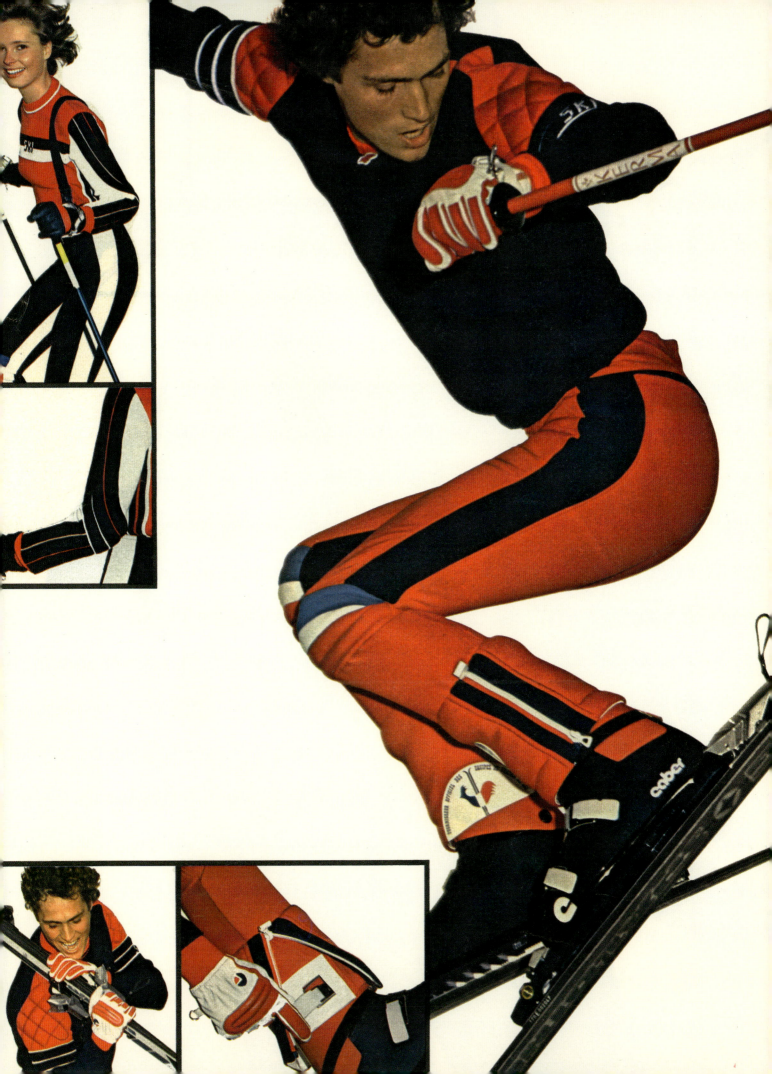

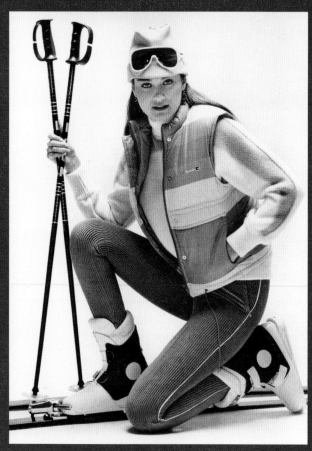
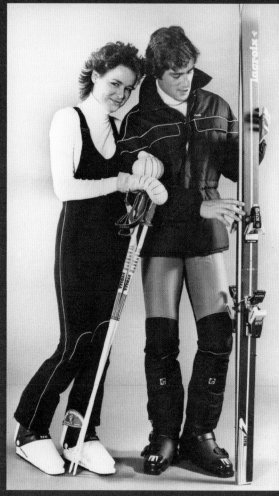

unskilled workers were scattered to the four winds, relocated first to southern Europe then to Asia. To make matters worse, Le Refuge reneged on its promise of refinancing, leaving Fusalp with no choice but to file for bankruptcy in 1984.

It was then that a group of former executives came up with "ProFusalp": a takeover plan that would allow the company to resume operations without moving from its existing administrative and creative base in the Haute Savoie. Simply put, the firm would be co-managed by a team of its employees under the supervision of an executive board. The timing couldn't have been better. The French Competition Authority cleared the takeover and Fusalp could immediately resume its activities. But the takeover wasn't going to be simple. Endless, often heated negotiations ultimately led to a wave of brutal layoffs and the closure of the last remaining production sites. Bogged down by the 1980s recession, work resumed at the Annecy factory with just 117 workers, following which production relocated first to Italy then Portugal, Belarus and finally Asia. It was in China that Fusalp found workshops offering technical and design capabilities that albeit not perfect, still priced "made in France" out of the market.

The battle for Albertville

The bailout plan aimed to keep the Annecy factory afloat by operating out of a single site in the Haute-Savoie. The factories in Saint-Jean-de-Maurienne, La Balme-de-Sillingy and Moûtiers had already relocated. This left only the Albertville factory, the core facility housing Fusalp's entire stock of goods. The plan was to transfer the stocks to the factory in Annecy (where the Fusalp Head Office was located). In the event, closing Albertville proved a financial and social catastrophe. The unions swung into action, preventing the liquidators from disposing of the stock and effectively halting operations. Seeing their takeover plan about to collapse, the liquidators fetched a bailiff and forced their way into the warehouse to take an inventory of remaining items and recover them. They ended up blocked in by angry union members and had to wait for the French riot police to come and rescue them. It took another court appearance before the stock could be recovered and trading could resume. Of the 1,200 workers employed by the

Left:
Focus on collections,
1980-1981.

A WAVE OF INNOVATION

various sites across Savoie and the Haute Savoie, only 117 remained at the Annecy site as a result of crisis and relocation. Such unrest was symptomatic of the tragic history of French deindustrialization. The so-called "Manufrance Affair", which took place in the same period, is another good example.

Joël Geyze was one of the executives on the takeover panel and ran the company for nearly 30 years after the takeover. "I really enjoyed it when we produced everything here, dealing with whatever came up and managing the entire production line. Our strength lay in our choice of materials and thanks to the proximity of our suppliers we were able to use materials of a very high quality.

"Besides the wave of factory relocations, we were also faced with the supply chain disruption caused by the arrival of mass-market sport and leisure retailers such as Decathlon, which was established in 1976. The rise of these superstores was a real blow to brands like us. Not only did they eclipse independent businesses but they also drove down prices, which in turn led to a dumbing-down of quality standards. Suddenly you had a whole plethora of inexperienced brands flooding the market with badly made, low-end clothes selling at unbeatable prices.

"Add to this the fact that Fusalp badly needed money and you can see why it was important to keep the brand alive by any means possible. So having mainly focused on winter sports, we moved into outdoor and summer gear.

"After the takeover, it took nearly 20 years to restore the company's image, meanwhile driving business growth through the creation of new brands such Virage, Voltige, No Panik and Zone Off, which spoke to the new fads for snowboarding and freestyle skiing. Enter exuberant motifs and crazy prints such as a snake smoking a joint ..."

In the 1980s when the slopes were decked out in "fun" style outfits, it was these fashion-driven brands that kept the business growing ... right up until neon and bright colors went out of style. Wherever skiing enthusiasts have gone, Fusalp has gone there with them.

Quick reactions and creativity ensure Fusalp an enduring presence in the story of skiing, 1980.

'When you think of the acrobatics we performed, it isn't hard to see why we needed such high performing ski suits.'

CHRISTINE ROSSI
26 GOLD MEDALS, 1981-1988

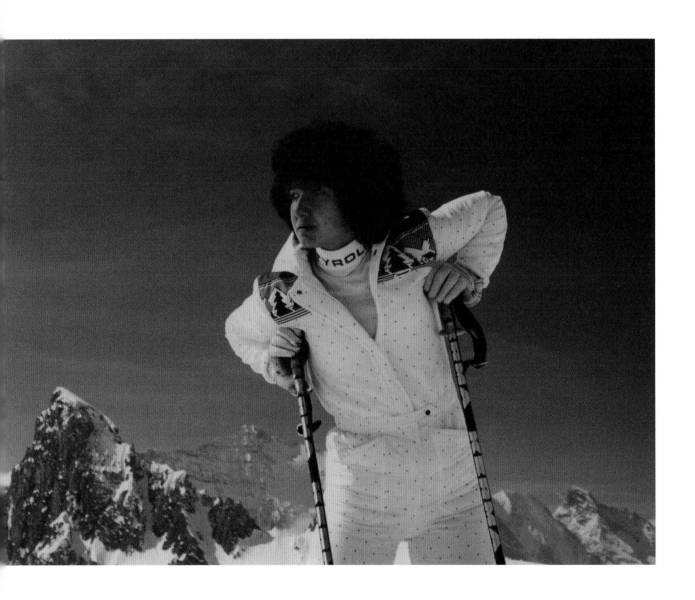

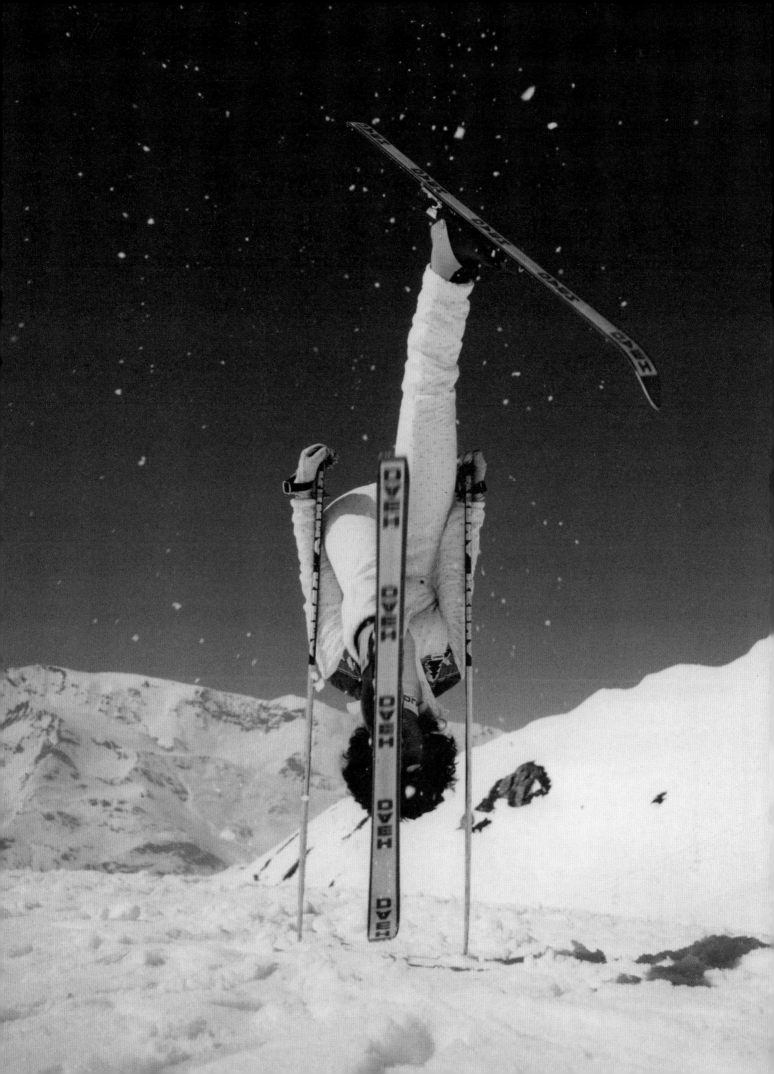

A WAVE OF INNOVATION

These new takes on style set the tone for new winter sports such as freestyle and aerial skiing. World and Olympic champion Christine Rossi was an ideal partner in this respect, and worked with Fusalp for many years. As the queen of freestyle, there was no one better placed to advise Nadine Portigliati on the choice of fabrics and the degree of stretch required.

"I really enjoyed working with Nadine on the first stretchable prototypes–looking for high-performance stretch fabrics that could cope with the particular demands of a discipline like ours. One look at photos from the time is enough to tell you how roughly we treated our ski suits and just how flexible they had to be ...

"It's quite simple really: in the period 1981-1986 I won everything wearing Fusalp. I was world champion in ski ballet for 10 years, winner of the world cup twice and also won a gold medal at the winter Olympics.

"Freestyle skiing these days is a demonstration sport, not a competition discipline. Back then, it perfectly captured an age when freedom was everything; it was the anything-goes antics of the hot-doggers that earned it the name "freestyle." But it remains one of the most demanding sports. We didn't realize it at the time because we'd been in at the beginning and spent years perfecting the technique. To become a peak performer, you needed to have done 10 years of skiing, 10 years of gymnastics, 10 years of trampoline and 10 years of dance ... Things have moved on a bit since–now you've also got ski slope style and big air... To my mind, that's a good thing–the fact that the discipline has adapted over time to suit every generation."

Previous pages:
At the beginning of the 1980s, Fusalp clothing adapts to new styles of skiing, most especially freestyle and acrobatic disciplines that call for super-stretchy materials. Here, acrobatic ski champion Christine Rossi in action at the start of the 1980s.

Right:
Annecy, 2021: Christine Rossi proudly shows off the Fusalp ski suit she wore then.

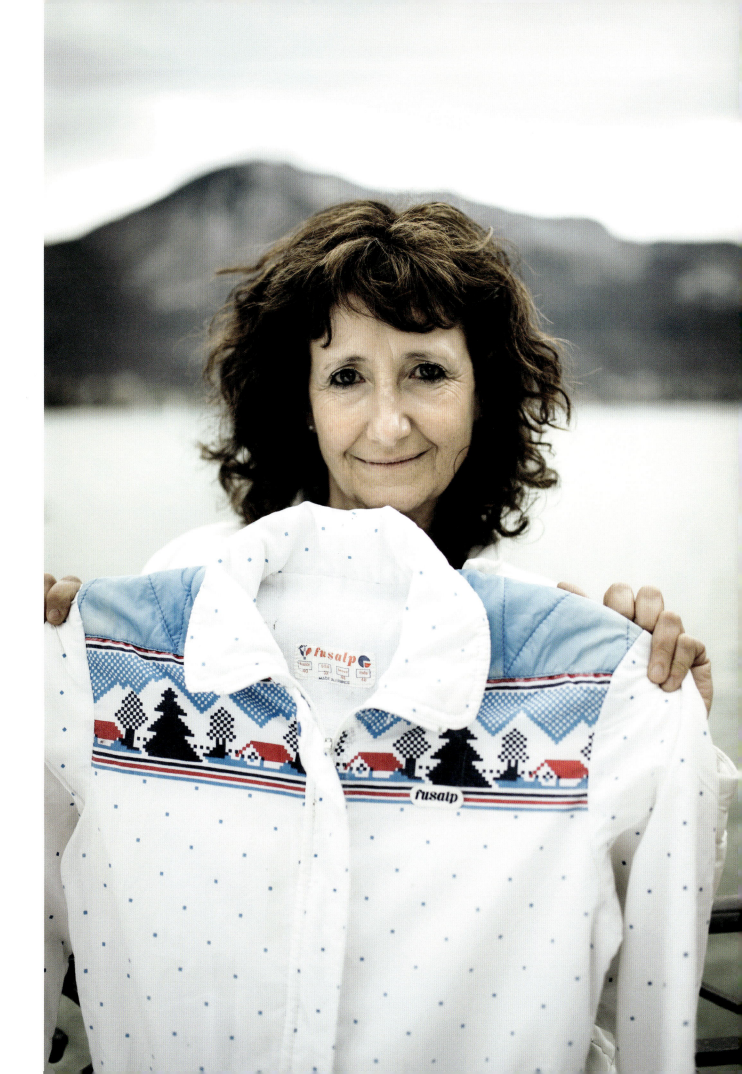

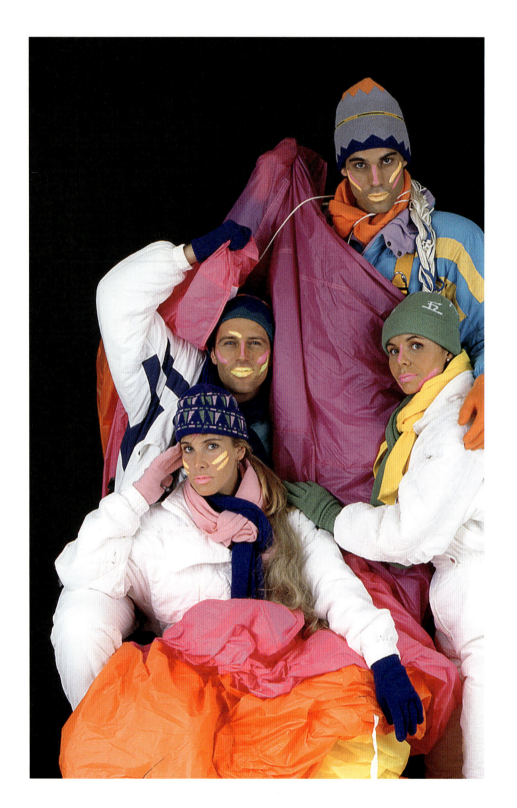

Left:
The brightly colored fun spirit of the 1990s!

Right:
Catherine Frarier, one of France's great acrobatic ski champions, in 1986.

Following pages:
Fusalp energy in 1979! Collage of Fusalp visuals 1976-1981.

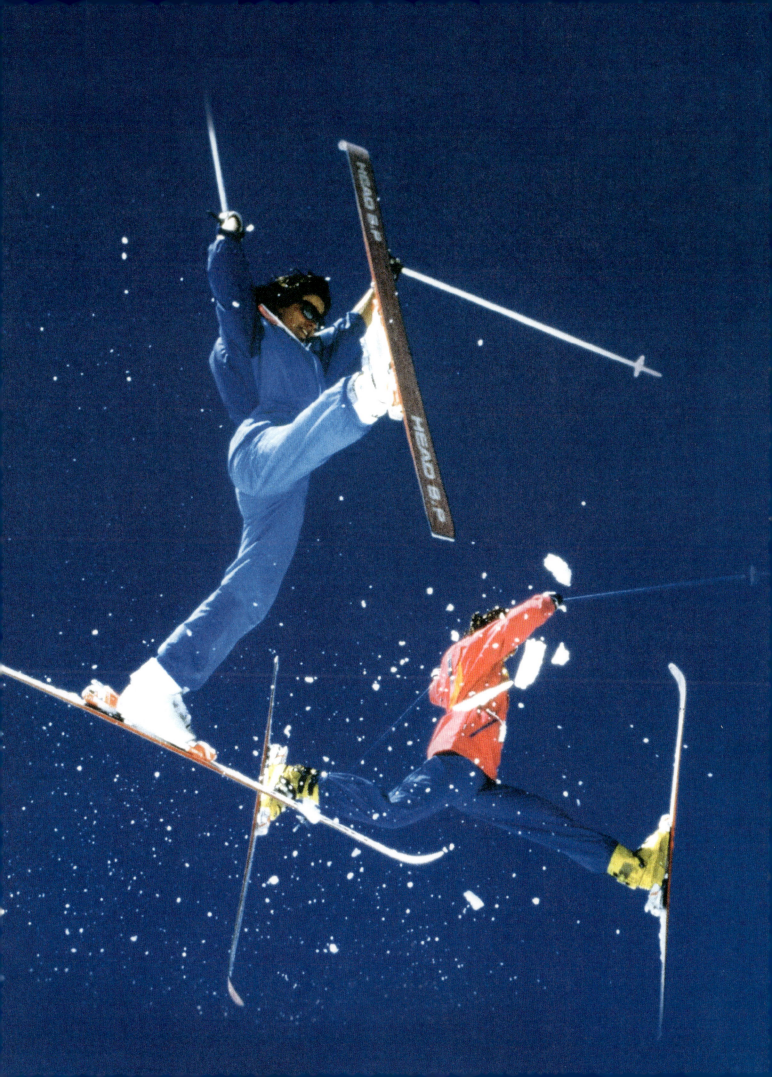

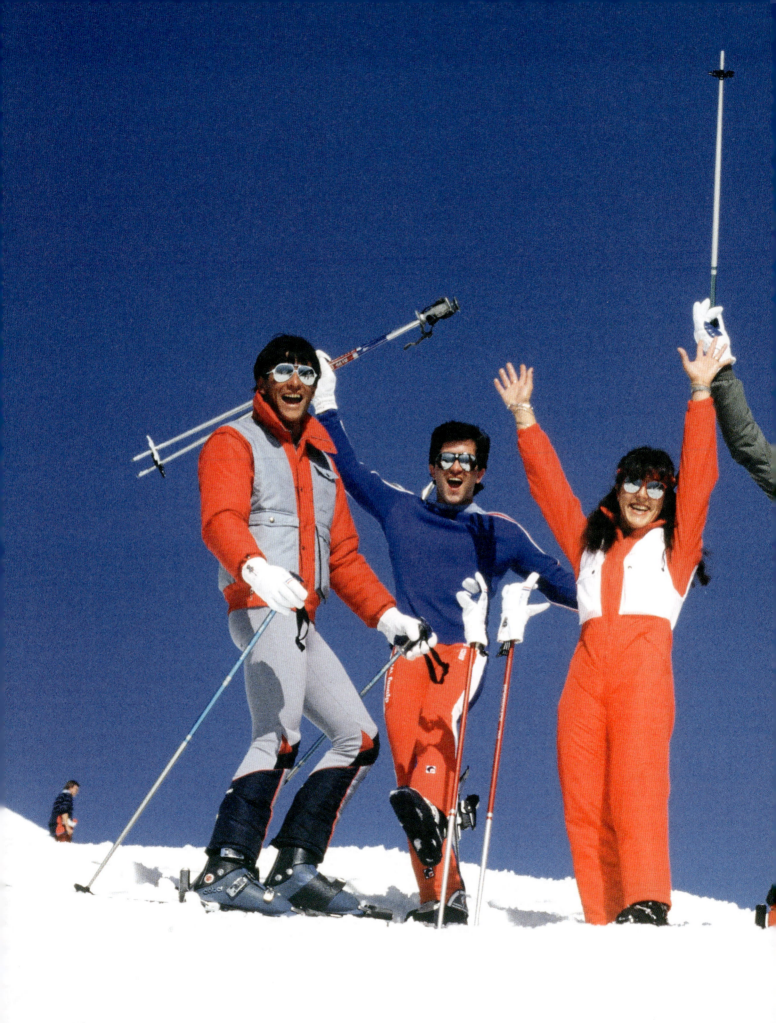

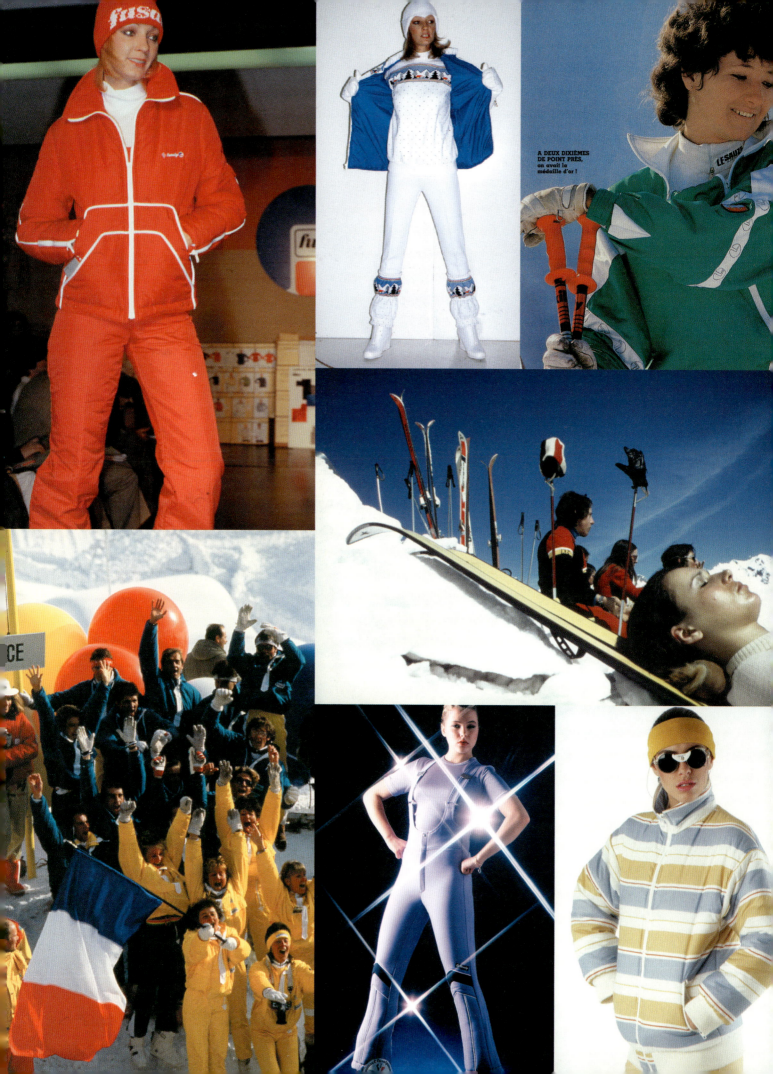

A DEUX DIXIÈMES DE POINT PRÈS, on avait la médaille d'or !

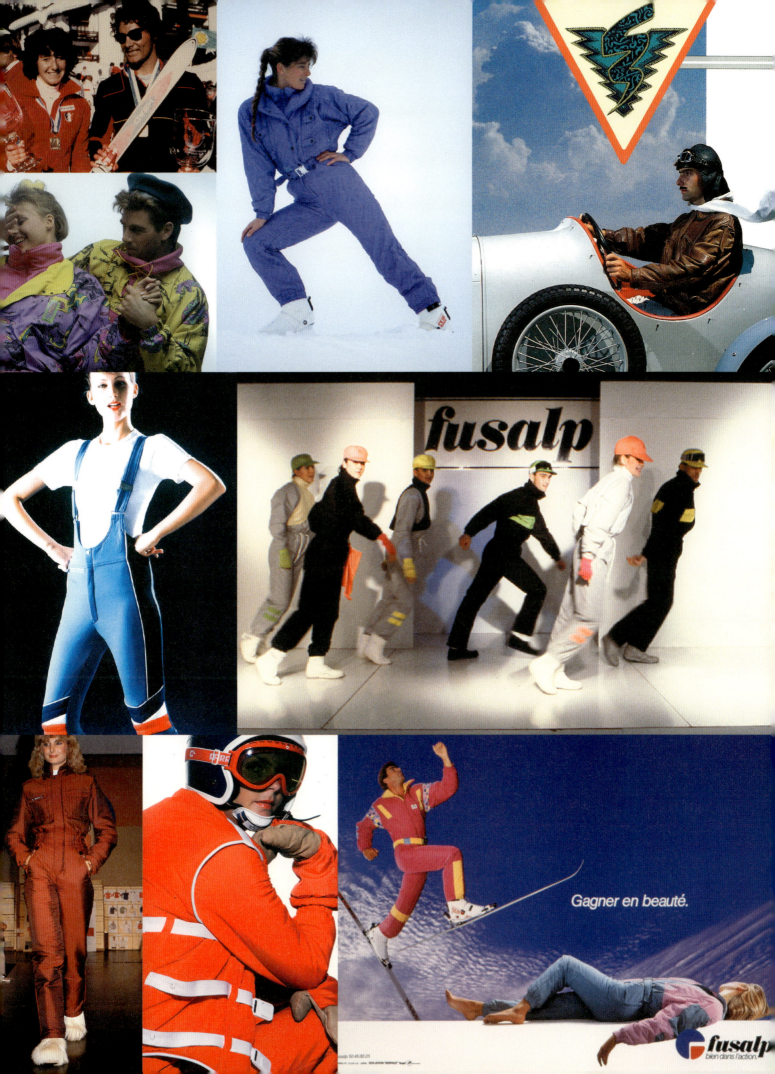

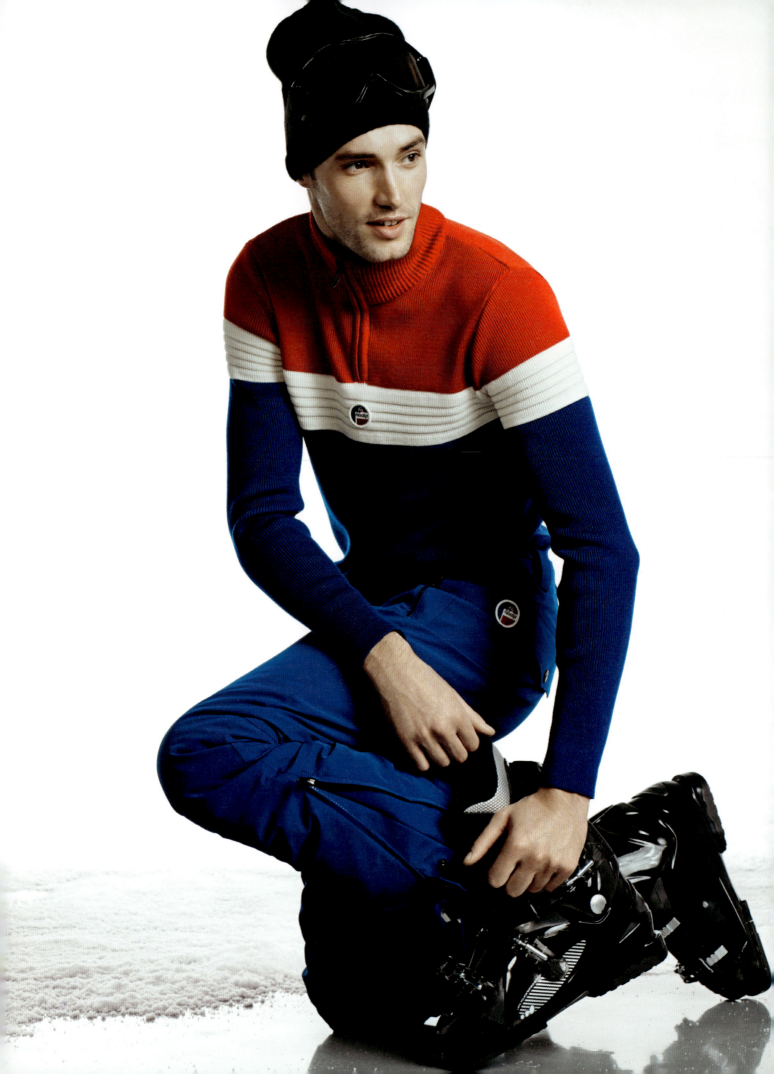

Toward brand rebirth

TOWARD BRAND REBIRTH

At the turn of the millennium, Fusalp made a comeback thanks to multisport gear and outdoor clothing. But what it mainly wanted was a return to its roots: to offload its subsidiaries and revive its original brand identity. The end of the century had been fraught with uncertainty, at the financial level and also in terms of design direction. As Joël Gleyze explains, the time had come to turn the corner: to restore the brand's DNA by following his intuition.

"I have always respected the history of Fusalp and firmly resisted skimping on the quality that was our hallmark. After giving it a lot of thought, we decided to bring back signature features like the protective "flanges" on ski-suits, our original logo colors, and the side bands. So we revived the logo and made an upscale move with our "1952" collection: a premium line we thought up with input from Nadine and the design team. Inspiration came clearly from 'seventies styles–a gamble certainly, but worth taking because it allowed us to exhibit at ISPO in the A category, among a bevy of international players. This gave the brand a presence in Germany and Austria, and also in places like South Korea and Japan."

"Joël Gleyze recruited a new sales director, Jean-Philippe Torgue, who did the rounds of the sector heads to find out what we made of this rough patch Fusalp was going through. I remember telling him that I had been a rep with the company for years and that if we wanted to innovate and succeed, it was vital to revive our original brand logo. For me, that was non-negotiable. The "1952" collection was launched in association with Italian designers Talenti–I thought it was terrific. For the first time in years I found myself looking at an item of clothing that moved me to the core. The vibe was pure Fusalp. Suddenly we were welcomed into classy boutiques like the one in Courchevel–it was like being born again."

Séraphin Vinco has been on the staff since 1978, and remembers how it was: "The "1952" collection featured 30 items, divided into six outfits for women and men, for dressing on and off the slopes. In those days Winter Sports marketing was happy to shake hands with lifestyle marketing. High-performance technical clothing was joined by chic, essentially feminine, après-ski wear that recalled the elegance of the

Previous pages, left:
The "1952" collection, autumn-winter 2014-2015. Last collection produced under the direction of Joël Gleyze.

Right:
Fusalp Autumn / Winter collection, 2017-2018.

skiing pioneers of the early 20th century. Just as Ingrid Buchner had wanted her sport outfits to double as street wear, so now the brand looked to do the same thing with technical ski gear. The writing was on the wall: Fusalp had to upscale its collections, assert the original brand identity and roll out its marketing strategy." New challenges in a new era persuaded Joël Gleyze to pass the baton so new talents could fill his shoes. In the words of the man himself: "There was no shortage of buyers, but for me the most obvious and attractive takeover candidates were Sophie and Philippe Lacoste, who were committed to pursue business in France, maintain the existing headquarters in Annecy and develop an international expansion strategy true to the origins of the brand."

> **"Sophie and Philippe Lacoste's determination to keep the business in France, to keep the headquarters in Annecy and develop an international plan faithful to the origins of the brand– this seemed to me to be the obvious and most encouraging way forward."**
>
> JOËL GLEYZE
> *FUSALP MANAGING DIRECTOR, 1984-2006.*
> *THEN FUSALP PRESIDENT, 2006-2013.*

Left:
Original logo, heritage colors, protective flanges, side bands: Fusalp trumpets its blueprint with the "1952" collection ...

Conquest begins anew

THE 2000s

CONQUEST BEGINS ANEW

When Sophie and Philippe Lacoste and Alexandre Fauvet bought out Fusalp in 2014, what they wanted from the start was a bold design direction. Product design management was placed in the hands of a French design studio and Italian designers Dario Talenti, with designer Mathilde Lacoste taking the helm now that the fabled Ingrid Buchner and Georges Ribola had left the company. Henceforth it was down to Mathilde to realize the brand's aesthetic ambitions. And there was no-one better placed to steer the creative process toward the collections of tomorrow.

Together, Sophie, Philippe, Alexandre and Mathilde strove to restore Fusalp's image by conquering new realms of design, the while giving the brand a truly global feel. Working as a foursome, they set Fusalp on a new course that equipped it for the challenges facing society today.

Offstage Philippe and Sophie Lacoste are siblings, but here they take the stage as the heirs to a family legacy of sport performance and art appreciation. The fact that they grew up in the Lacoste family business is proof enough of their solid understanding of the problems surrounding modern, high-performance textiles for sportswear and street wear.

At the core of their entrepreneurial drive are unshakeable values–principles they applied when reviewing their myriad options as the scions of the Lacoste business empire. Their aim was to live a human adventure and generate a type of cultural wealth, not to invest to make money. It was an idea at the crossroads of moral and aesthetic commitments that went far beyond skiing and clothing.

Their relationship as siblings had already stood the test of working together. Time had shown that they thought alike, when working with Lacoste or on philanthropic endeavors such as the Porosus project–an endowment fund that supports emerging young talents in the fields of sports and the arts. It is this generous impulse to nurture young people that has helped shaped "Fusalp S'Engage," a broader commitment that finds expression in many different forms, all of them strictly benevolent.

Previous pages:

In 2014, Fusalp drew strength from its mountain DNA to make an entrance on the urban scene. Pictured here, detail of the Sayamaike Museum created by Tadao Ando, Osaka, Japan.

Right:

The Fusalp management team: from left to right, manager Sophie Lacoste; president of the board of directors Philippe Lacoste; and CEO Alexandre Fauvet.

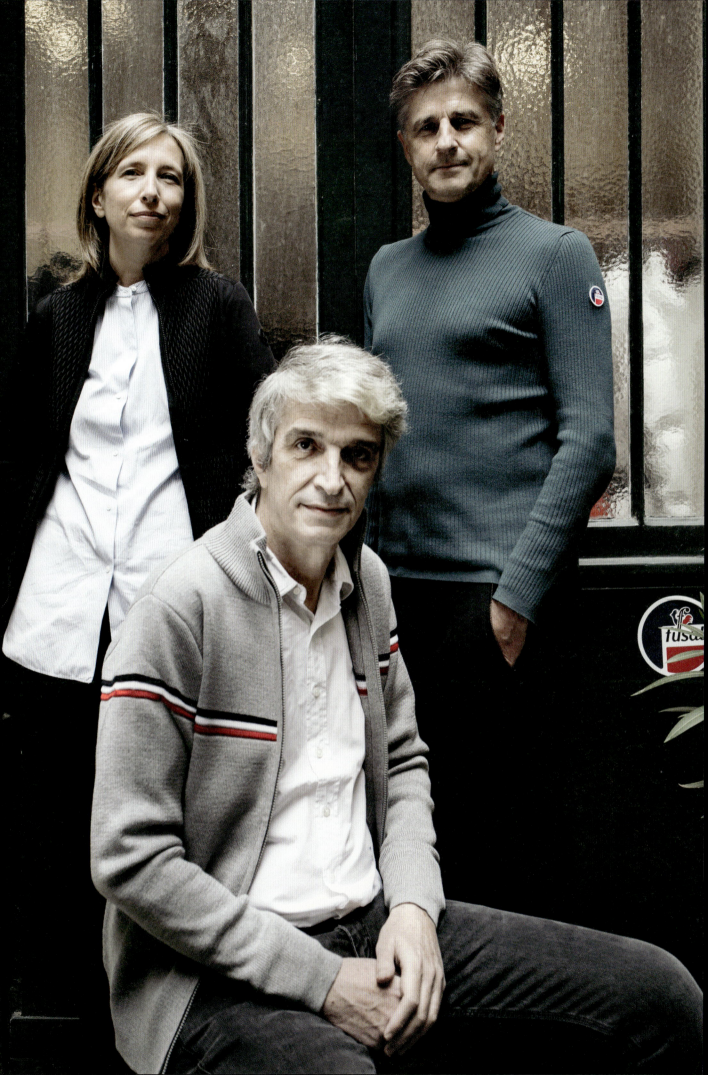

CONQUEST BEGINS ANEW

Behind it all is a lifelong project full of twists and turns that come together in Fusalp: "A French company born of a legacy of craftsmanship and enduring expertise; a brand that was losing its sparkle but still potentially capable of having an emotional and aesthetic impact; and a business that promised to revive the economy of the Haute-Savoie."

It was this company that Sophie and Philippe Lacoste bought out in 2013, no doubt partly inspired by their attachment to the land where their mother was born. Now co-presidents, the duo have run the business ever since, with the support of CEO Alexandre Fauvet.

> **"A French company born of a legacy of craftsmanship and enduring expertise; a brand that was losing its sparkle but still potentially capable of having an emotional and aesthetic impact; and a business that promised to revive the economy of Haute Savoie."**

SOPHIE LACOSTE
CO-PRESIDENT OF FUSALP

Horizons open up on Annecy Lake, with the prospect of a renaissance fueled by the brand's rich technical and stylistic heritage.

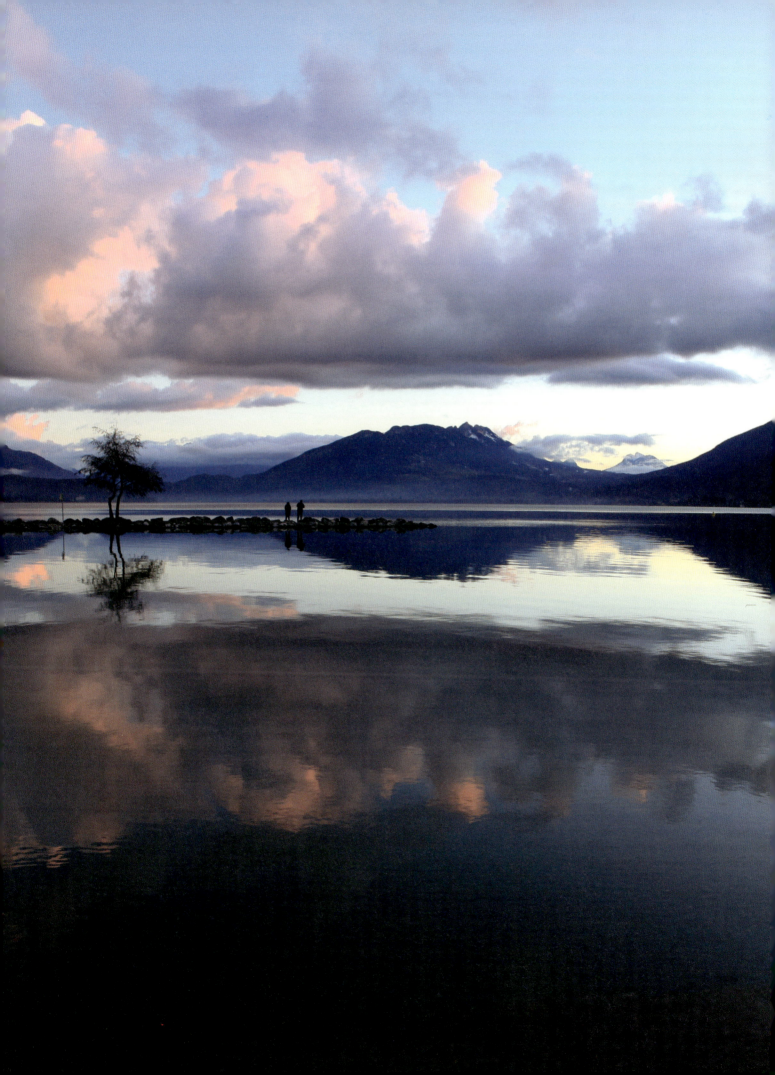

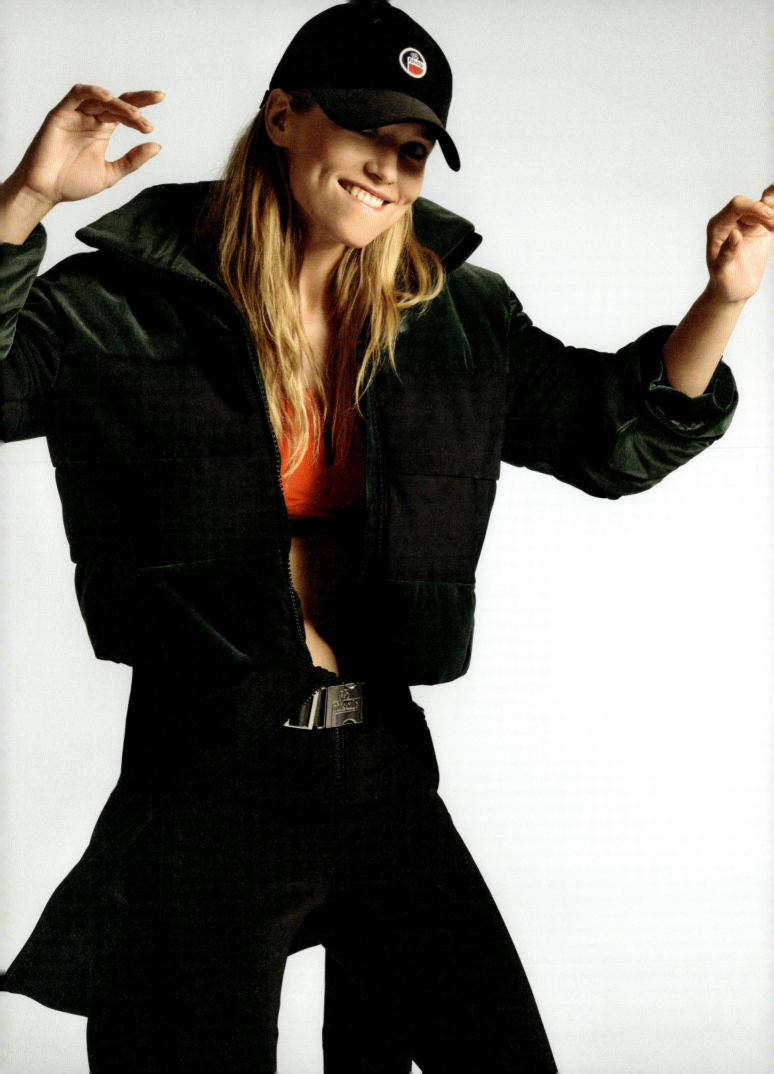

Back to
the roots of
performance

BACK TO THE ROOTS OF PERFORMANCE

What started as an adventure in men's tailoring soon morphed into a think-tank on skiwear. Sporting performance became the key to equipping athletes with the tools they needed to succeed–improve their tech savvy skills thanks to the insights of Fusalp's invaluable collaborators, the champions themselves. The result was an entirely new aesthetic that appealed to mountain enthusiasts of every stripe.

When Alexandre Fauvet arrived at Fusalp, he had a very clear vision for the business: "Sustainability comes naturally to Fusalp because everything we make is made to last. In a way, we are still writing the story of the brand–drawing inspiration from our roots, delving into our legacy to write the future. Always knowing that champions were the making of the brand. It's really exciting to invent clothes that have no precedent–a technical and aesthetic challenge certainly, but no less fascinating!"

So it was that some of the most iconic athletes associated with the history of Fusalp were invited to step back on stage as brand ambassadors. For Fusalp-clad ski aficionados, it was a Dream Team.

Alexandre Fauvet wanted to meet Antoine Dénériaz from the moment he became CEO of Fusalp: "To my eyes he embodies the values dear to our heart. We share the same views on what a company like Fusalp can bring to a region–be socially responsible and help sports people develop their skills.

"Subsequently we renewed our former ties with the ski federations; to cultivate ties with Asia for instance we needed to be visible at the Pyeongchang 2018 Winter Olympics in South Korea, where we had a presence alongside Prince Albert of Monaco's Alpine race team. We strive for visibility across different disciplines through partnerships on different levels. Speaking of which in 2021 we took another big step by becoming the official supplier to the hugely promising British Alpine squad."

Fusalp's keen understanding of the issues at stake is embodied in its privileged relationships with former athletes like Marielle Goitschel, Léo Lacroix and Annie Famose, and in the global assignments it entrusts to

Previous page:
Fusalp Autumn / Winter collection, 2019-2020.

Right:
Fusalp Autumn / Winter collection, 2018-2019.

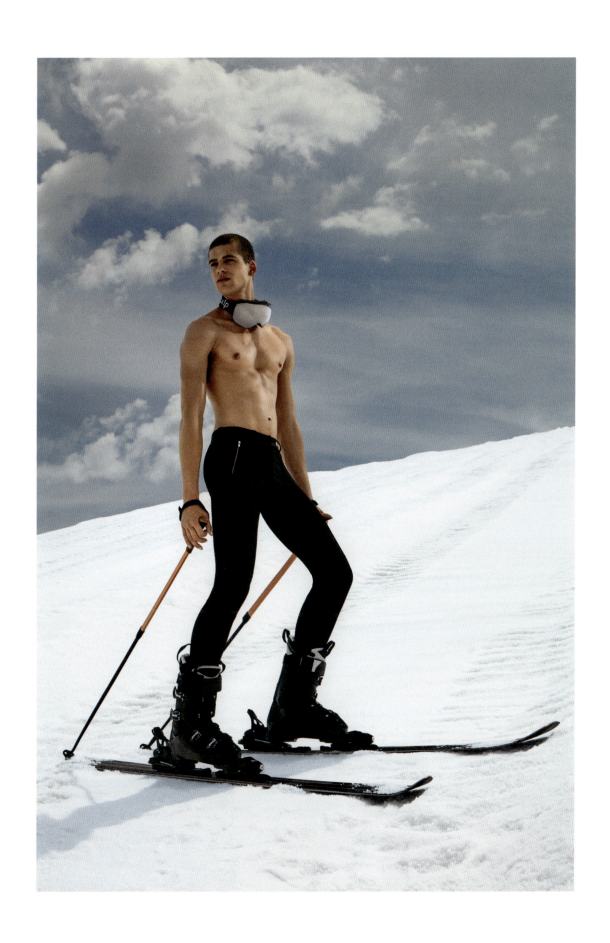

❛"Fusalp will always be remembered as the ski-clothing brand that dressed the French teams in the Killy and Goitschel years ... That, and a whole story of skiing that dreams are made of. Pictures in Winter Sports magazines, old VHS tapes –everywhere you looked you saw people wearing Fusalp. In fact, many of those outfits are returning to the slopes today.❜

ANTOINE DÉNÉRIAZ
*DOWNHILL CHAMPION AT THE TURIN OLYMPICS
AND FUSALP AMBASSADOR*

❝What I love about Fusalp is that you can't mistake it for something else. It's got a brand identity so strong that you couldn't hide it behind another logo if you tried.❞

CLAUDIA RIEGLER-DÉNÉRIAZ
ALPINE SKIER AND FUSALP AMBASSADOR

BACK TO THE ROOTS OF PERFORMANCE

champions with an exceptional track record. Claudia Riegler-Dénériaz is a good example.

"I started skiing very young, age 3 or thereabouts, in Austria. I won my first title at the age of 10 and immediately got selected for the national team. Six years later, in 1992, I decided to go it alone and left for New Zealand.

"I was the Austrian slalom champion and won four World Cup victories. Then in 2003, aged 26, I quit and married a man who specialized in schuss. Me, the queen of slalom! After that, I launched a program to help young people in New Zealand, give them the benefit of my experience.

"What I really wanted to do–and this may come as a surprise–was perform in a one-woman show. Or at least I did until an agent in Vienna said 'you know Claudia, all the funniest stand-up comics are actually clinically depressed.' Not for me, I thought, and ended up joining Fusalp–which is just as much fun.

"I knew about them because my father-in-law had kept every single French ski magazine dating back to the 1950s. That's where I learned the story of the brand, in this precious stash of his. He loved it when we talked about Fusalp's glorious past, back in the days of athletes like Annie Famose and the Goitschel sisters. They were the pioneers of skiing–the people who invented it all. It can't be easy for young people knowing that their predecessors did it all and won it all"

It was this long-standing tradition of performance that prompted the desire to support young athletes through a project mentored by Fusalp brand ambassadors, ski champion Claudia Riegler-Dénériaz and Olympic champion Antoine Dénériaz. Meetings, shared experiences and summer classes are just some of the many activities aimed at helping young ski talents to advance their careers. The program was launched in the course of the 2019-2020 season, spearheaded by Marie Bochet, the most decorated French athlete in the history of the Winter Paralympics with 93 World Cup victories to her name; and Mathieu Faivre, who claimed a double world championship in 2021, that's 53 years after Jean-Claude Killy ... All season long,

Previous pages:
Antoine Dénériaz,
Olympic downhill
champion and Fusalp
ambassador.

Left:
Alpine ski champion
Claudia Dénériaz in the
tuck position – forward
to the future.

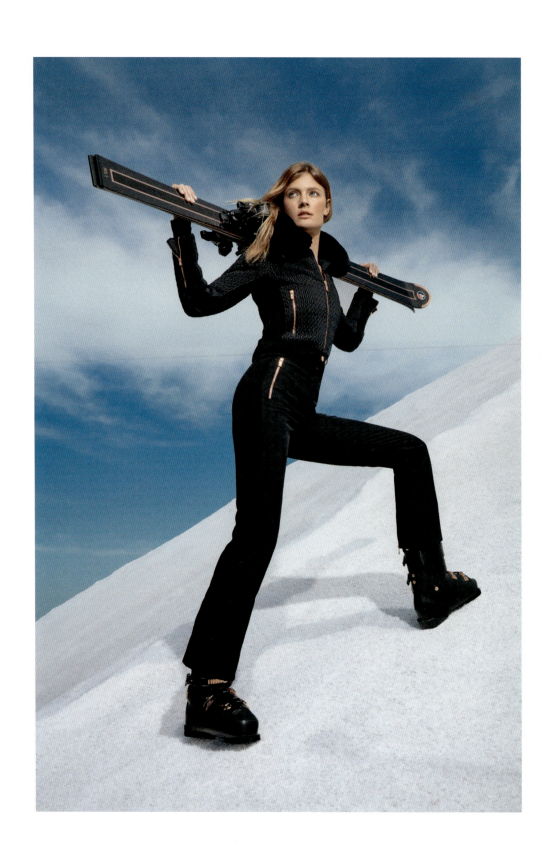

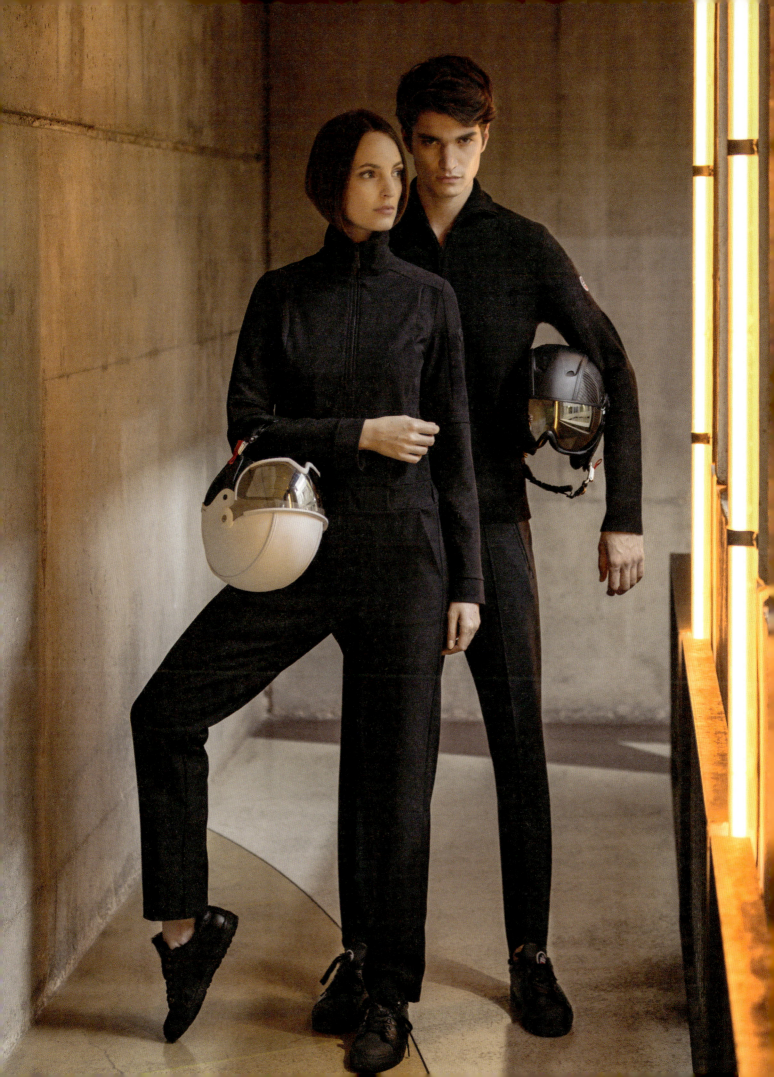

BACK TO THE ROOTS OF PERFORMANCE

mentors and competitors strove to encourage budding young talents, among them Norway's rising star Kaspar Kindem (fourth in the World Alpine Skiing Championships in Norway); and French skiers Karen Smadja-Clément (21 years old, placed first in the French Alpine Skiing Championships); Sacha Theocharis (ninth at the Pyeongchang 2018 Winter Olympics); and Léo Anguenot (fifth in the Giant Slalom Junior World Championships).

In short, this is a project driven by knowledge-sharing and curiosity.

Guardians of knowledge

When the new team took the helm at Fusalp they were careful to hold onto those people who had watched the brand evolve over time. From the ground floor to the top floor, you find seasoned executives for whom skilled workmanship is the beating heart of garment manufacturing. People imbued with the culture that was the making of the brand, who feel a strong sense of loyalty to their company, But for their exacting standards and diligent service this adventure in high-tech would never have been possible.

As Sophie Lacoste likes to put it, family businesses are driven by a sense of entrepreneurship. For her, the brand's style identity and the company culture are one and the same, founded on the same simple, shared values: joie de vivre, boldness, elegance and non-negotiable standards. Fusalp's corporate culture must be seen through the prism of these core values, bringing together new talents with those long-term employees who maintain and transmit the brand legacy. Every detail is carefully thought out to embody a collective endeavor where good human relations come first—from the importance attached to keeping the head office in Annecy, the place where it all started, right down to working conditions and the workplace environment.

Fusalp prototypist Rose-Marie De Olivera remembers how it was: "I joined Fusalp in 1999 as a model maker. My job was to cut out and assemble garments based on the templates provided by the pattern designer, then send these to the workshop with instructions for the sequence of assembly. The problem with pattern making is that it

Previous pages:

Left: Fusalp Autumn / Winter collection, 2018-2019.

Right: Photo shoot for the 2018-2019 Fusalp street collection at the national dance center in Pantin.

Right:

Joie de vivre, boldness, elegance and technical performance: Fusalp's core values embodied here in its 2017-2018 autumn-winter collection.

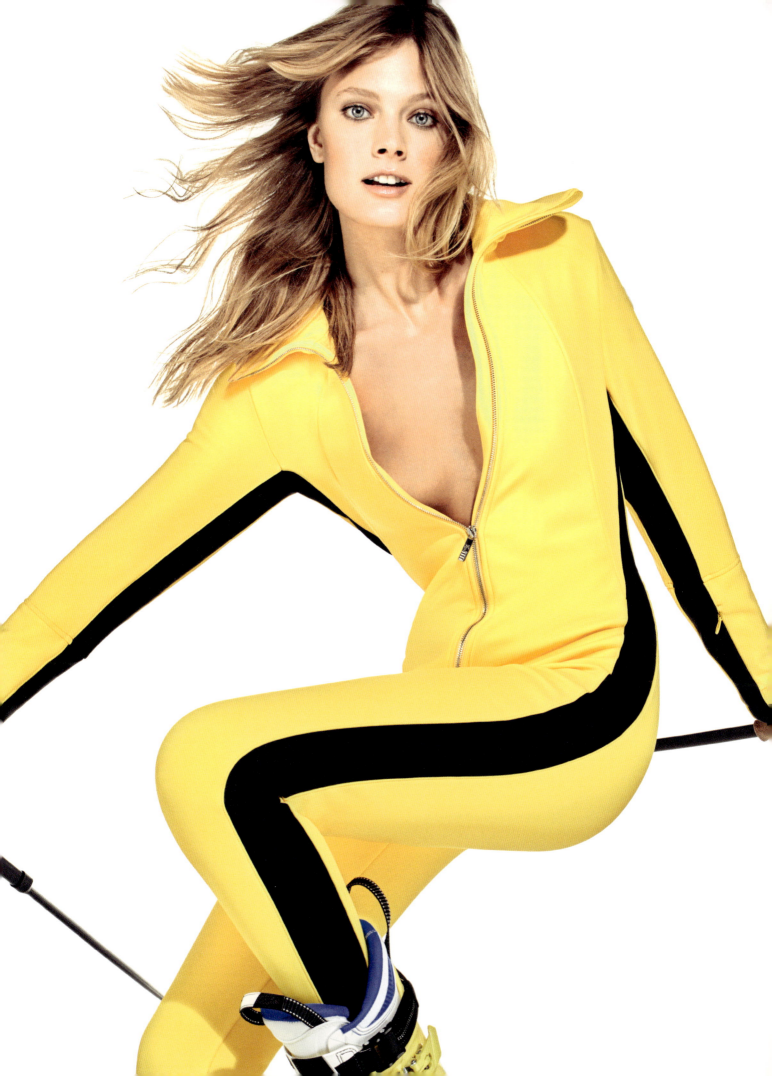

' The extraordinary thing is that these garments last forever–and the better the quality of the product, the less you need after-sales support. These bobbins behind me for instance date from when the factory first opened. The thread is top-notch, like all of our materials, starting with the fabrics right down to the zippers and snap-fasteners. Sometimes garments are sent in for repairs and no matter how highfalutin the fabric, I still do things the old-fashioned way. Works a treat. '

ROSE-MARIE DE OLIVERA
FUSALP PROTOTYPE MAKER SINCE 1999

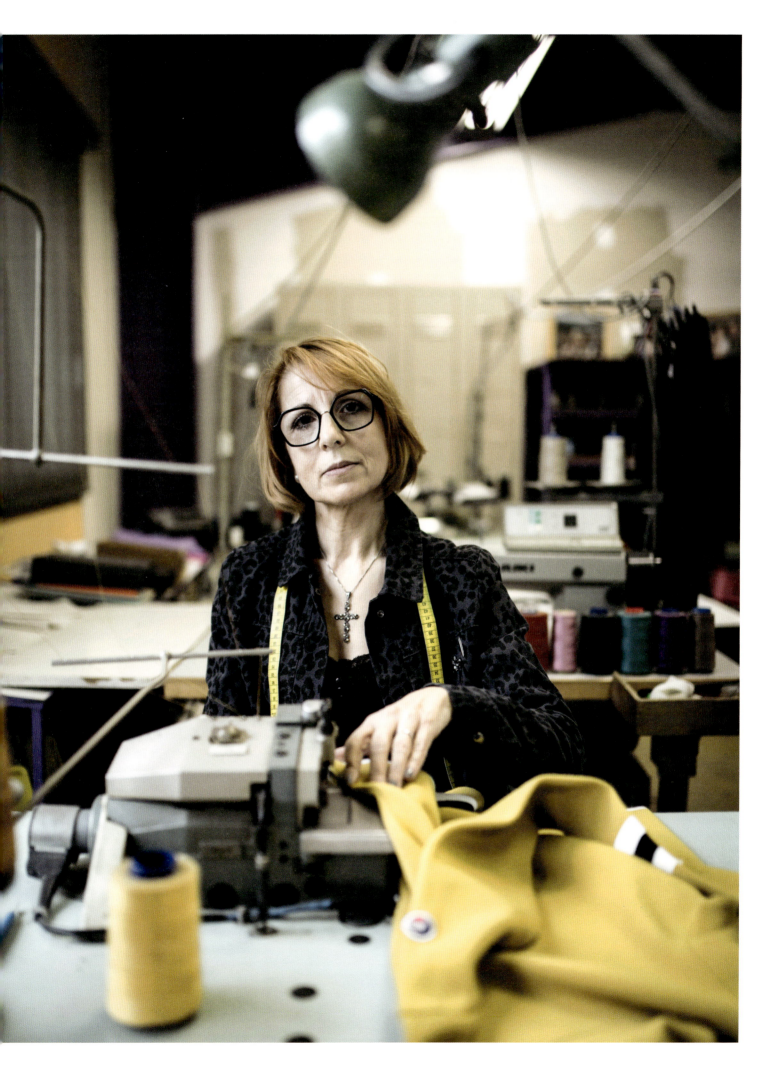

Previous pages:

Prototype maker Rose-Marie de Oliveira, in charge of after-sales support since 1999

Right:

Fusalp street style: structure meets streamlined fit for dynamic performance. Autumn-winter urban collection 2018-2019, at the Centre National de la Danse.

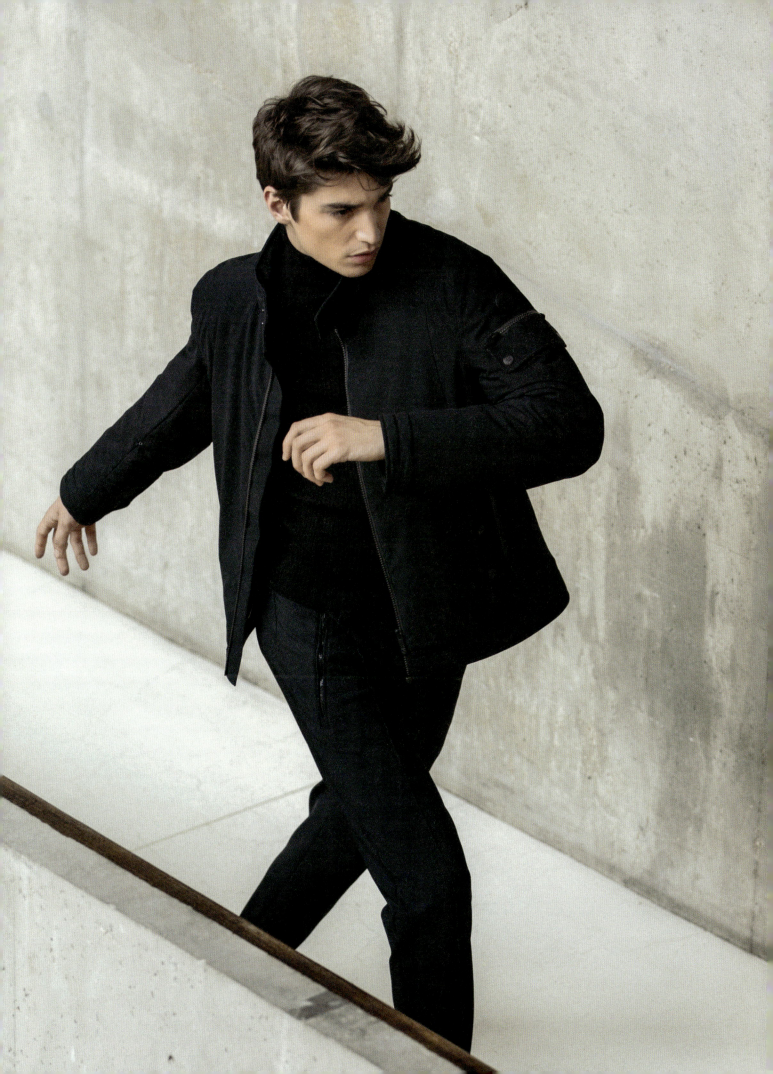

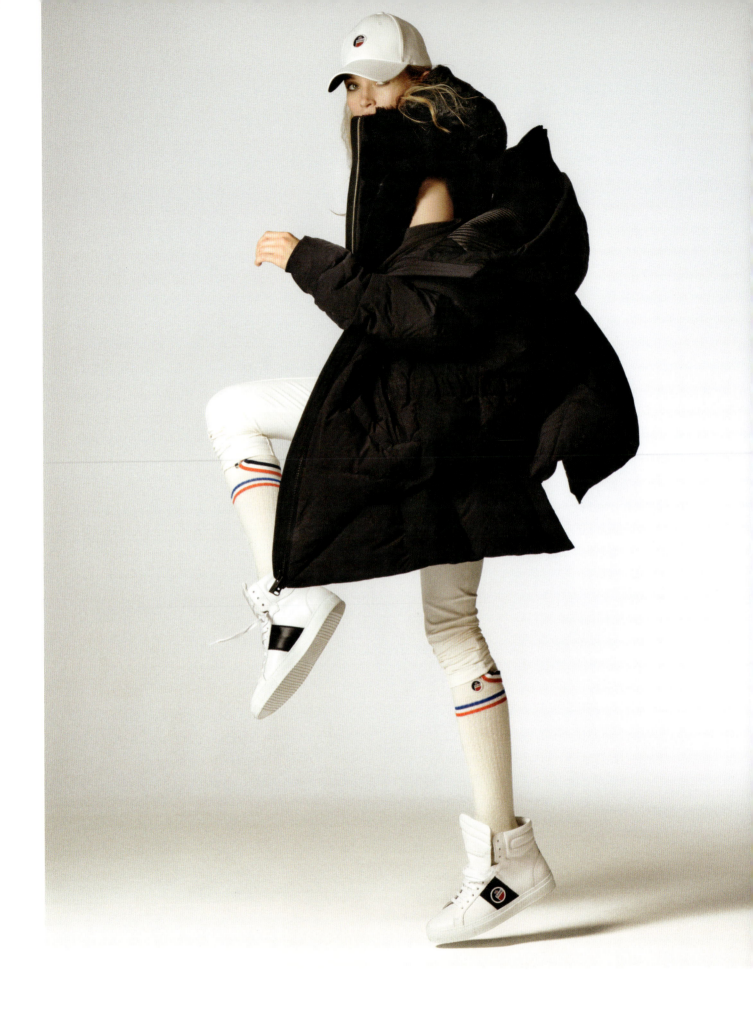

BACK TO THE ROOTS OF PERFORMANCE

leaves no room for error. You can't afford to be out by as much as a hair's breadth. I would advise on the design and make mock-ups for the workshop. Back then we were making ski suits from more than 350 different parts.

Later I transferred to after-sales support where I was put in charge of garment repairs. The extraordinary thing is that these garments last forever–and the better the quality of the product, the less you need after-sales support. These bobbins behind me for instance date from when the factory first opened. The thread is top-notch, like all of our materials, starting with the fabrics right down to the zippers and snap-fasteners. Sometimes garments are sent in for repairs and no matter how highfalutin the fabric, I still do things the old-fashioned way. Works a treat."

Adds Fusalp sales representative Séraphin Vinco: "I've been with Fusalp since May 1978, when Georges Ribola was still here. I was hired as a driver and would transport materials from one factory to another. In those days Fusalp had production facilities in several places– Albertville for anoraks, Moutiers for pants and so forth. Afterwards they transferred me to trade shows. Fusalp was one of the first brands to display its Winter Sports collections on the runway–Paris, Milan, Munich, Salzburg, London, Barcelona, Zurich and other venues.

"From 1986 onward I started working as a sales rep and I've been a sales rep ever since. Fusalp for me is a historic logo. When I first joined, Decathlon had yet to become recognized and some brands were clearly identifiable. Fusalp didn't need a label–you knew at a glance who it was.

"After the Lacoste team arrived, it was like going back to the old days, the brand as it was then. Reconnecting with our roots has put our creativity back on track. As if the adventure were about to start all over again but with even greater things in store. These days we're true to the spirit of the brand as it used to be–sober, simple chic, top quality fabrics through and through. Back to the days when one look told you this was a garment made by Fusalp. That's what a label is all about isn't it?

I left school at 13. Everything I know, I learned on the job. Working first

Left:

Fusalp bounces back after the Lacoste takeover and reconnects with its original design spirit. Autumn / Winter collection, 2019-2020.

Following pages, right:

Portrait of Séraphin Vinco, sales representative since 1978.

'I left school at 13. Everything I know,
I learned on the job. For me you can
only sell with emotion when you sell
what you love–love it and wear it. Me,
I'm dressed head-to-toe in Fusalp. It's a
personal choice. Don't tell anyone, but
if it were up to me I'd make the famous
'Léo' ski-suit available off the peg ...'

SÉRAPHIN VINCO
FUSALP SALES REPRESENTATIVE SINCE 1978

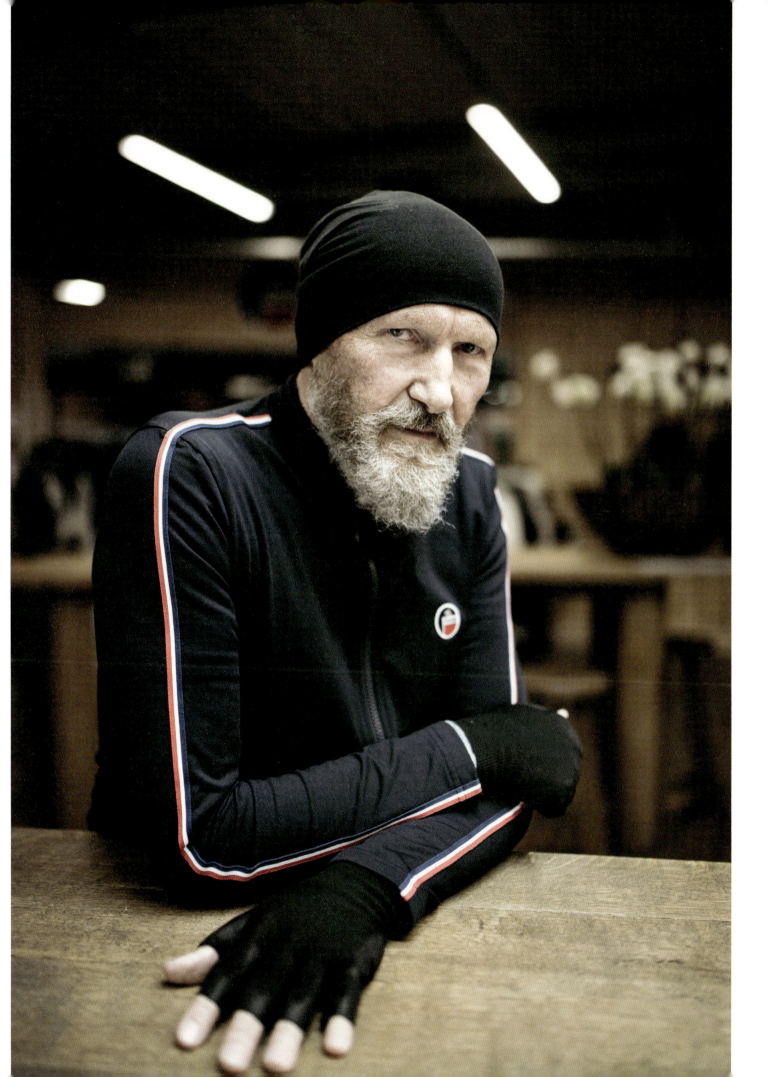

BACK TO THE ROOTS OF PERFORMANCE

as a cutter helped me understand how pants are made, which in turn made me better at selling. For me you can only sell with emotion when you sell what you love–love it and wear it. Me, I'm dressed head-to-toe in Fusalp. It's a personal choice.

Don't tell anyone, but if it were up to me I'd make the famous 'Léo' ski-suit available off the peg …

Nadine Portigliati on fabrics: "The fabrics are grouped in categories. Everything you have here comes from trade shows, all the latest collections, classified according to supplier. Once we've finished choosing fabrics for different seasons, we group them by type, for example costume fabrics like velvet, pearlized fabrics, silver-finished textiles and prints.

Here you've got casual-wear fabrics with matte finishes for more of an urban look. The streetwear we make is no less modern in terms of membranes and protective finishes …

"Then there are your stretch fabrics–versatile enough for any application, from pants and shorts through t-shirts … here you've got the lightweight textiles we use for our puffer jackets, with inductive sensors, membranes plus a wide range of finishes including matte, print and pearlized.

"You could say I live for the life of textiles".

Previous pages:
Inside the Fusalp workshops in Annecy, May 2021.

Right:
Nadine Portigliati inside the Fusalp workshop, discovering the archives.

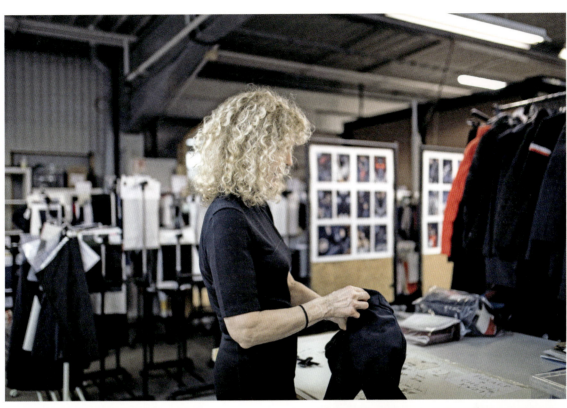
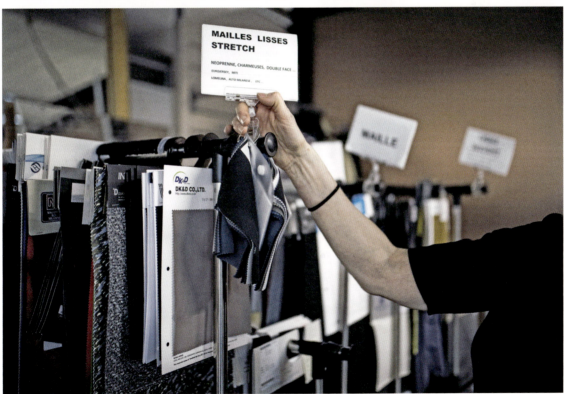

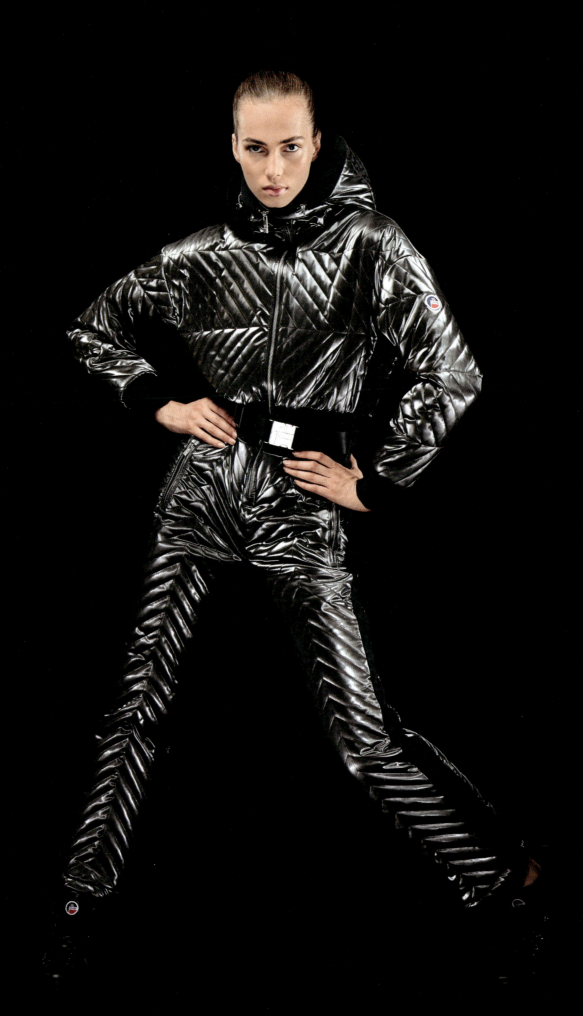

21ST CENTURY AESTHETICS – FROM SKI LIFE TO STREET LIFE

The purpose of clothing is to protect the wearer, be comfortable and allow freedom of movement. Given that, says Alexandre Fauvet, Fusalp has always sought to apply different aesthetics so as to produce complete clothing ranges versatile enough to wear on any occasion. The objective is hybridization: modifying outfits to offer a new wear. So a product originally intended for skiing can now also be worn in non-athletic settings. You have clothes that can switch from the slopes to the street and vice versa.

New recruit Elisabeth Malcor works in project development, thinking up ways to make the transition from the athletic allure of the body in performance, to the elegant allure of the body in everyday life. "I've worked with different creative directors, like John Galliano at Dior... it always amuses me when they ask how I manage to make our Fusalp ski suits so fabulously alluring! It's a form of beauty, certainly, but it's also a design aesthetic offering not just technical functionality but also great versatility. We started in skiwear but today people want ski outfits they can wear in town and the other way around. That way skiing can trickle through to different lifestyles, which is perfectly in tune with Fusalp's DNA: a brand that started out with a tailor making garments to enhance and emphasize the silhouette. It makes complete sense for us to move into everyday wear with more relaxed ski outfits that anyone can wear, on the street or on the slopes. Then there's the democratizing effect of making the advantages of high-tech clothing available to the public at large."

For Fusalp, thinking up a new line of clothing and a new image also means forming close ties with new partners on the fashion scene. A good example is "Colette," the beloved Parisian boutique and epitome of Parisian chic, which joined forces with the brand for the widely acclaimed Fusalp x Colette capsule collection. It was an experience that brought home the essence of the Fusalp identity: a slim, chiseled style born of meticulously selected, high performance materials.

Fusalp designs the garment of the future, aiming for "hybridization": at home on the slopes but equally at home elsewhere. Pictured here is "Shiny". Autumn / Winter collection, 2019-2020.

‘A creative director is a like a sponge. Someone able to immerse themselves in the history and style of a brand and come up with something entirely new. Someone who can look back and look forward at the same time. Never too far back, never too far forward, always right on time. In a nutshell, someone with the talents of our female creative director.’

PHILIPPE LACOSTE
CO-PRESIDENT OF FUSALP

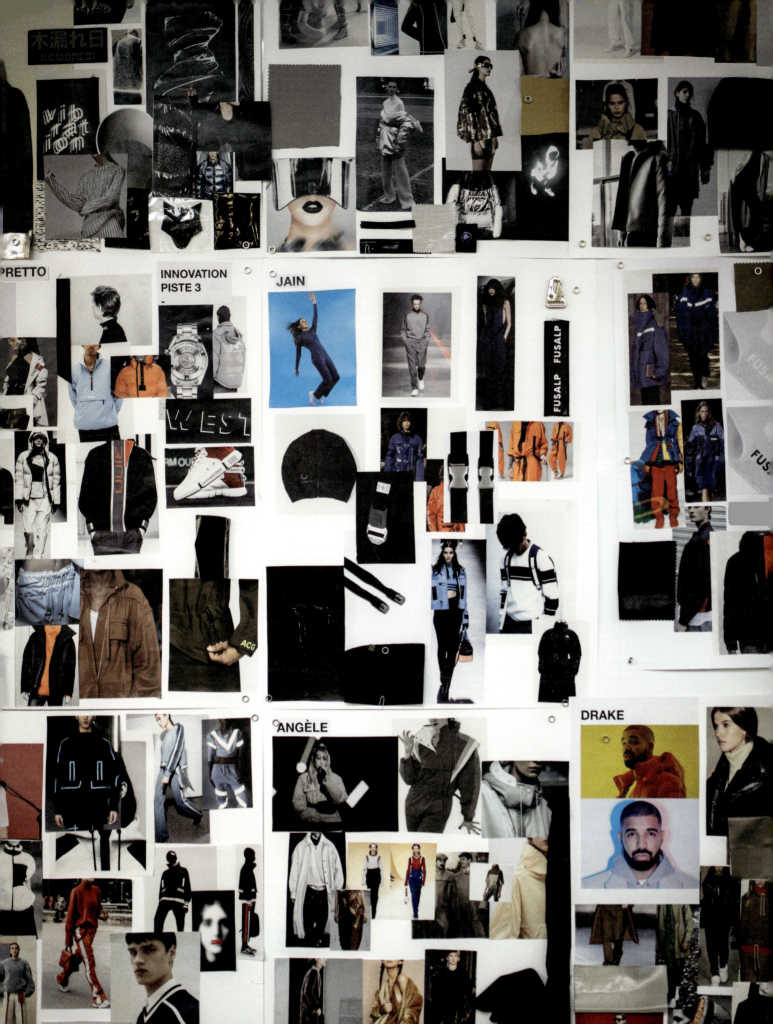

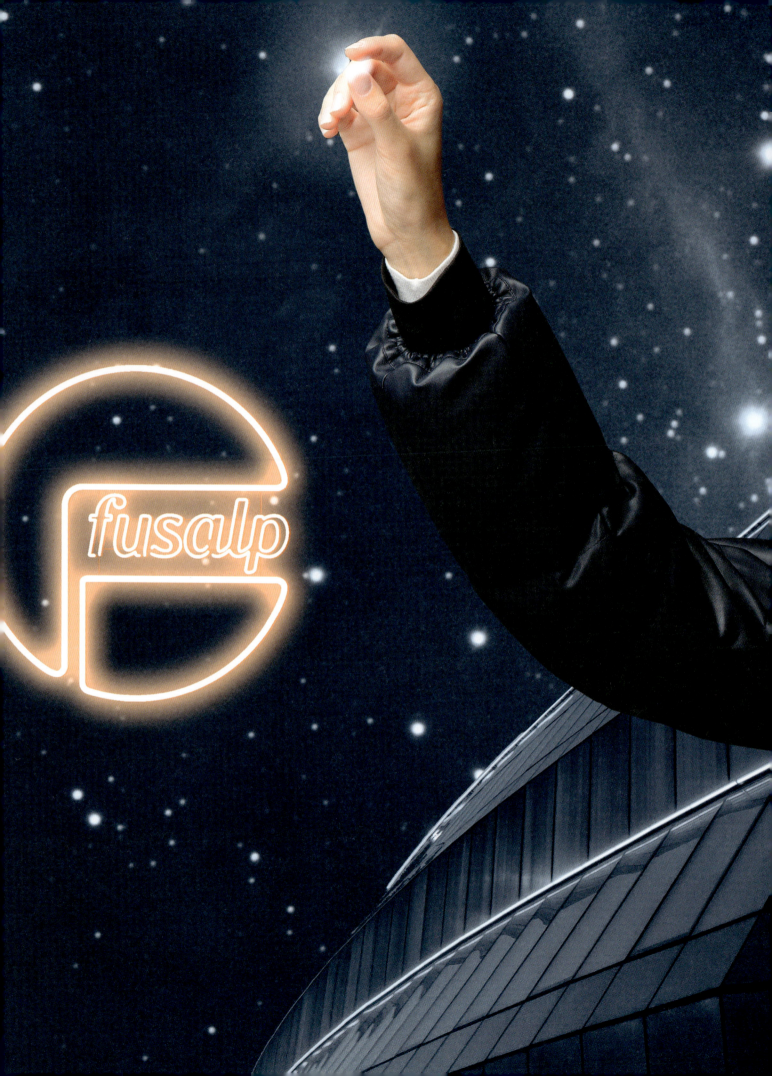

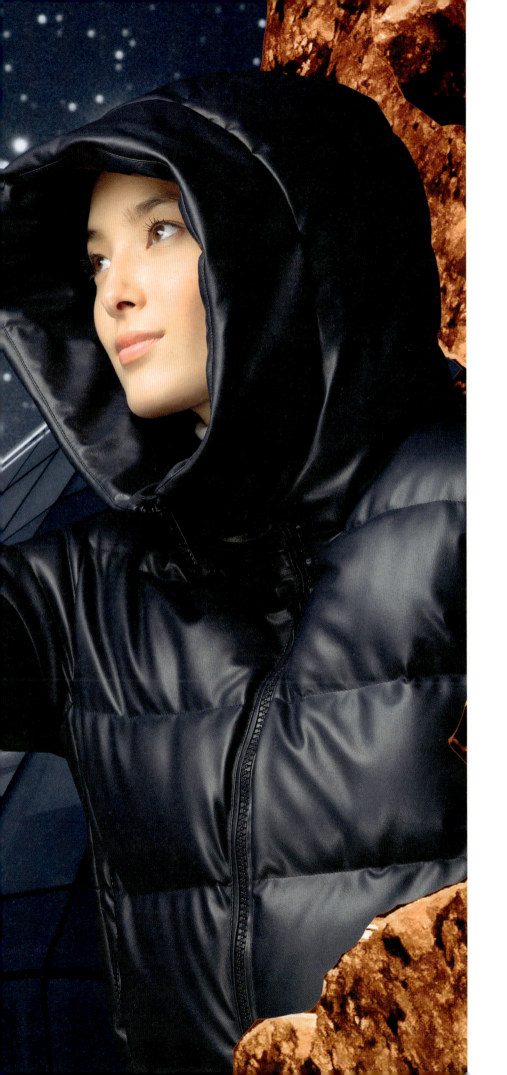

Previous pages:

Fusalp artistic director Mathilde Lacoste shows her mood boards.

Left:

Fusalp stamps its mark on the ready-to-wear market with an urban look that oozes sport-chic elegance. Autumn / Winter collection, 2020-2021.

21ST CENTURY AESTHETICS – FROM SKI LIFE TO STREET LIFE

These collaborative partnerships enable Fusalp to keep pace with innovation and tune into new trends. In 2020, for instance, the brand teamed up with Chloé on a skiwear capsule collection with an eye to the slopes as well as urban settings. This was the first time the two French labels had worked together–a meeting of visionary minds that produced a range of technical outerwear, knitwear and accessories that speak elegant active-wear. Chloé and Fusalp were both founded in 1952, one in the heart of Paris, the other in the French Alps. They quickly saw how to weave together their two equally strong signature styles to create a co-branding that combined the unique lines of the one with the colors and subtle motifs of the other. Fusalp design for movement meets Chloé prints. What you get is an unusual but intrinsically elegant capsule collection merging everyday comfort with effortless chic. Add a touch of vintage sportswear, and you have a winning example of encounter-based design. Collaboration is the key to a quest for hybridization that makes the Fusalp label impossible to resist.

For Alexandre Fauvet and Philippe and Sophie Lacoste, there was no-one better qualified to steer their aesthetic strategy and bring the company into the 21st century than designer Mathilde Lacoste. As creative director since 2014, Mathilde now follows in the footsteps of Georges Ribola and Ingrid Buchner, reconnecting with a tradition that puts creativity center-stage thanks to intrepid personalities willing to take risks–people who are ready to quit the beaten path to create the clothing of tomorrow.

"I joined Lacoste as a newly qualified fashion and textile designer, with experience in photography and graphics. I had just graduated from the Duperré School of Applied Arts and needed to find a job fast because my mother was ill. You never know what's going to happen next, do you?

"At Lacoste, I worked on the full range of polo shirt colors, looking to ensure a consistent look and feel across all markets. First I was creative director for womenswear, menswear, golf clothing, etc; then I built a project development team where we tried out all kinds of new products, let our imagination run wild.

Bold, bright and unashamedly urban: the brand enters the 21st century under the guidance of new artistic director Mathilde Lacoste. Autumn / Winter collection, 2019-2020.

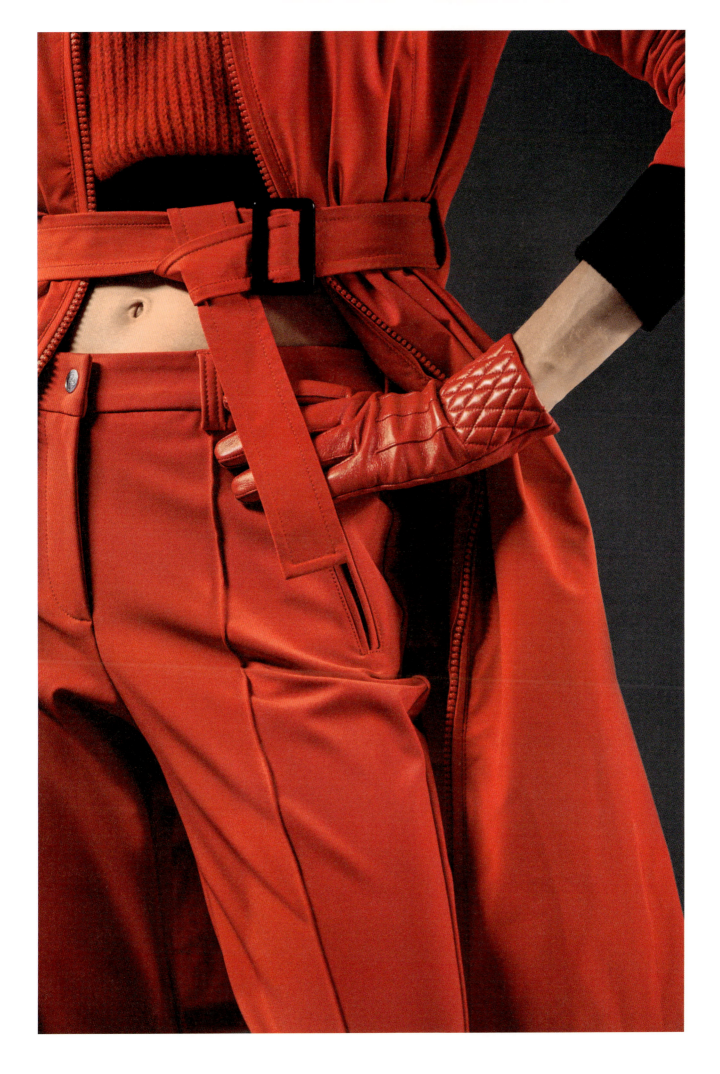

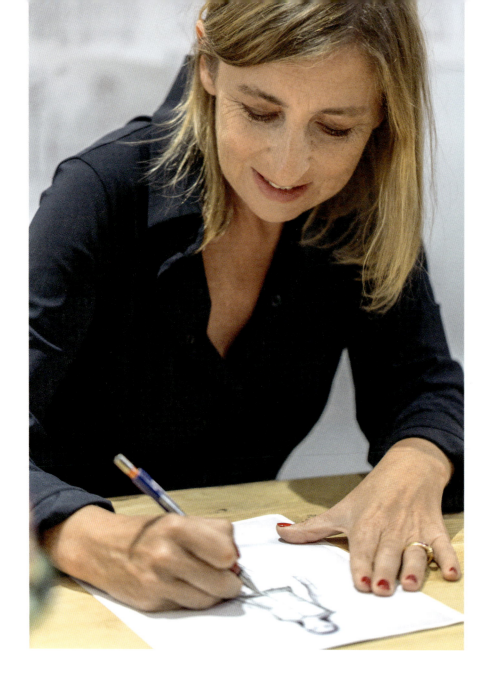

'Today our production is equally split between ski outfits and multi-purpose town wear, with our collections expanding every year. The spirit that drives it all, the engine of the business if you like, is this constant interplay between skiwear and streetwear.'

MATHILDE LACOSTE
ARTISTIC DIRECTOR OF FUSALP

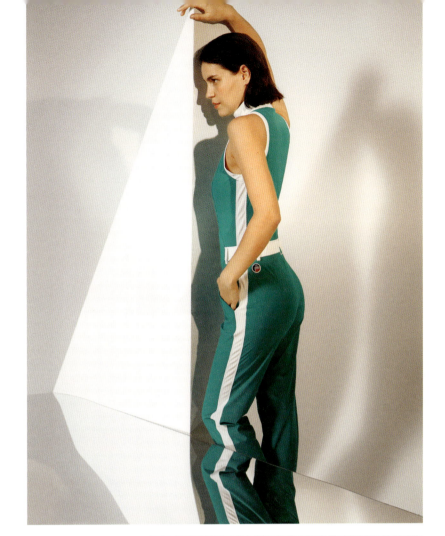

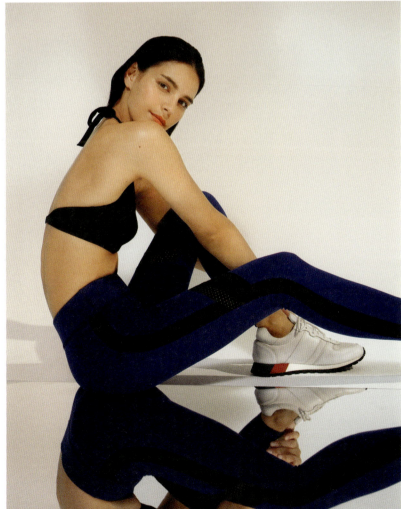

Left:
Today's artistic director Mathilde Lacoste in Paris, September 2020.

Right:
Fusalp "activewear": a fusion of urban and ski wear that showcases the silhouette. Spring / Summer collection, 2020.

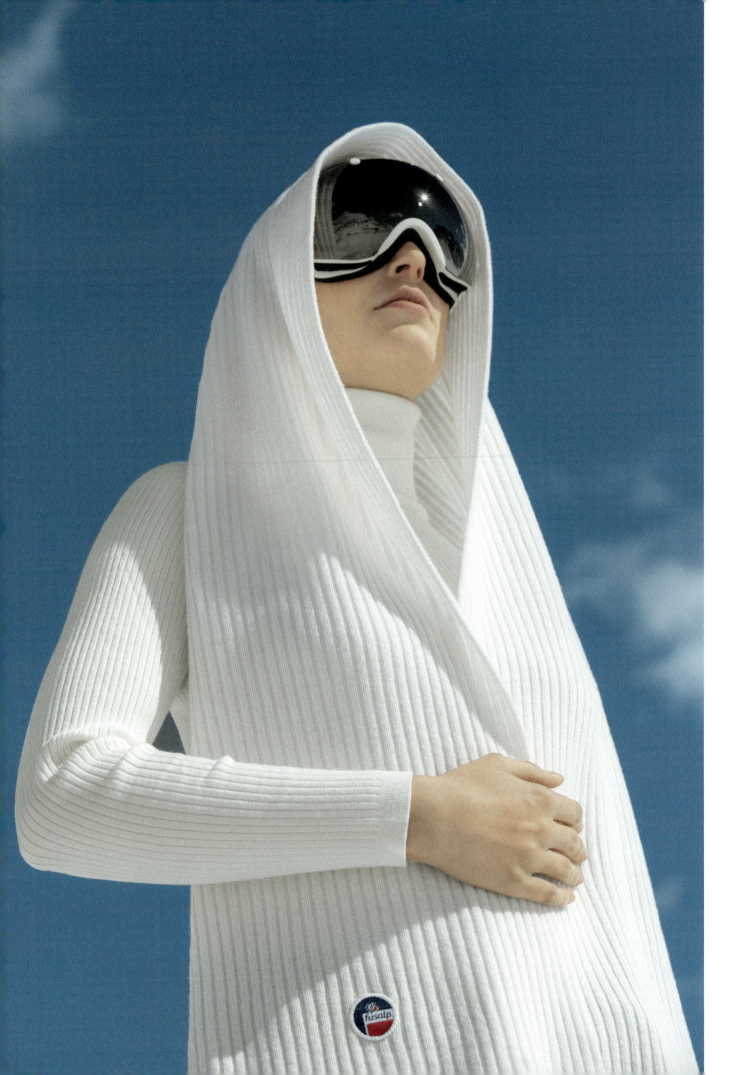

21ST CENTURY AESTHETICS – FROM SKI LIFE TO STREET LIFE

"When I joined Fusalp in 2014 my brief was to immerse myself in their history and revive the original brand spirit. Always a tricky proposition, not least because it means making hard decisions about which profitable products to drop in favor of a style identity built on an altogether different approach.

"What struck us about the existing team, "us" being Alexandre and me, was their huge potential for technical excellence. Take for instance Nadine Portigliati. She really knows her stuff when it comes to materials and works hard to build good supplier relationships with the best in the business.

"Once you know the materials, you can begin to consider construction, which is a real challenge given that materials react differently depending on what's under the top layer: the type of wadding or down, the kind of insulation, and so forth. The choice here makes a big difference so we run a whole series of tests to see what works best. Now, with the drawings already in hand, I start to put the garment together. I determine the overall range of colors and group them by theme to tell a particular story. But it's all up for grabs until the very last moment. Finally I put things back in order, according to theme, and create the silhouette along with a color palette to match. It's a bit like being a magician, adding blocks of color and seeing what happens …

"At the end of this process you've got a garment you can wear skiing or on the street. So the challenge is to have a clear idea of modern streetwear, at a time when sportswear has never been more versatile. I really like turning it into something that goes everywhere. I sound out everyone in manufacturing to see what they think: the different teams, graphic designers, sales people … everyone gets a say.
Sometimes, when I make really elaborate garments, people say, "Who's going to wear that?" Never mind. If my instincts tell me that's where I've got to go, then I charge ahead regardless.

"I get a lot of support from specialists in ski making and design. For me, it's no bad thing to take the market by surprise sometimes, particularly in the US where they go really bold with color – much more so than here. You French, they say, you only wear black, navy blue and gray.

A stripped-down aesthetic, or flattering the figure Fusalp-style. Autumn / Winter collection 2018-2019.

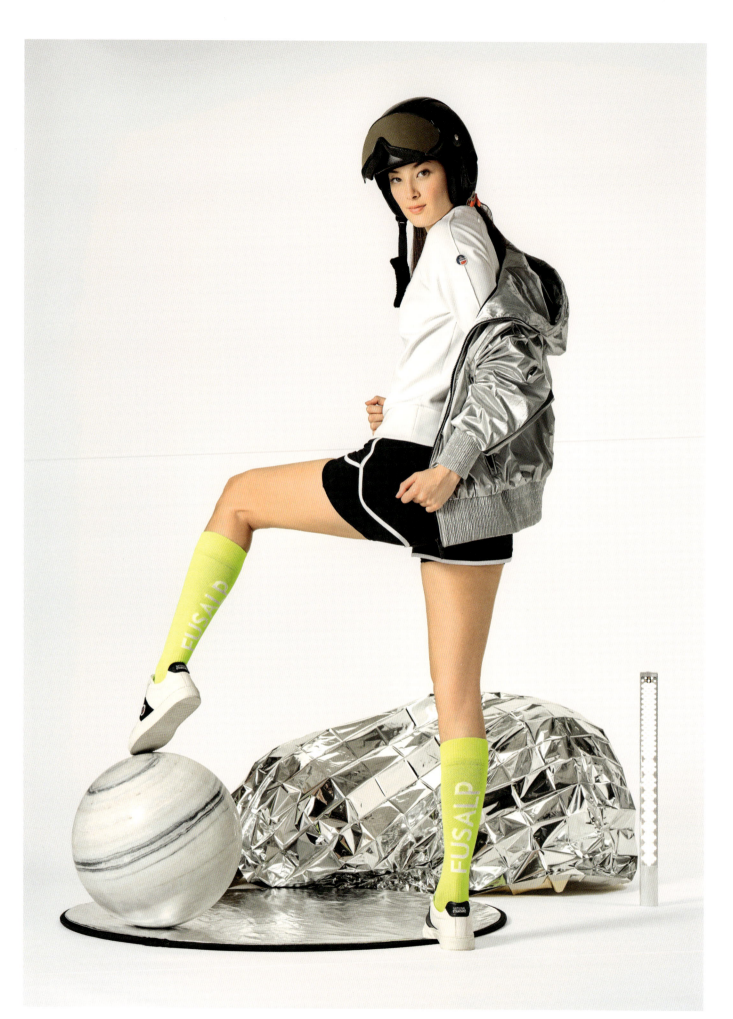

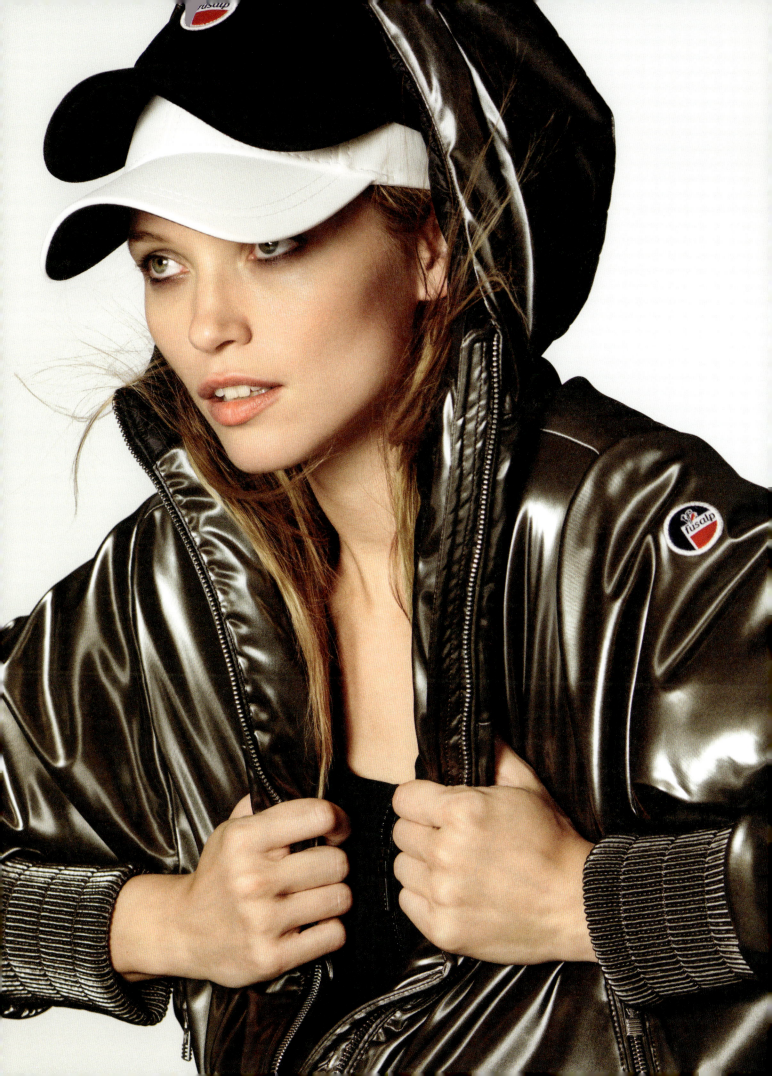

21ST CENTURY AESTHETICS – FROM SKI LIFE TO STREET LIFE

"I'd say too that since joining Fusalp I've learned enough about skiing to move into streetwear with no holds barred. When I left school all my friends wanted to go into haute couture, but I was always more attracted to a career in sports, hence the appeal of Lacoste. For me, it made sense to work on products that combined aesthetics and functionality. Products made with unusual materials that don't just transform the way you look but make you feel good as well. What I have in mind for the future is a relaxed style in tune with modern life– the school-run, doing yoga, going to the office or traveling. Oversize coat, stylish pullover, elegant sweater, practical leggings or, at least while coronavirus keeps people working from home, how to look professional from the waist up.

"I look for integrity in everything I do. Our materials aren't just for effect. They're engineered for wellbeing, carefully researched and carefully finished no matter how long it takes. Aesthetics go hand in hand with a kind of integrity that strives for durable clothing made to withstand the pace of a world moving at breakneck speed. Integrity is my moral compass. Just because one piece meets with success doesn't mean you can trust things to remain the same. Fashion is notoriously fickle so you can't just go on churning out the same "item" every year, no matter how successful it is. It's like little children who always want you to read them the same story. Reassuring certainly, but in my job you have to be prepared to take risks.

"Then there's the pleasure dimension: no matter how serious I am about my work, this is about clothing, and clothing must always be a pleasure. So there's a playful side to the work. Your typical men's wardrobe for instance, tends to be more straight-laced than fanciful so there's plenty of room to get creative–change the graphics to achieve a younger look.

"Drawing for me is always a lengthy process. Thinking about the proportions, the architecture. Our products aren't just a flash-in-the-pan fad. They're also about styling and making products that last. Hence their timeless feel.

Previous pages:
Left: Fusalp spring-summer collection 2021.
Right: Fusalp Autumn / Winter collection 2019-2020.

Right:
"Technical and creative research has its playful side too." Mathilde Lacoste, autumn-winter collection, 2020-2021.

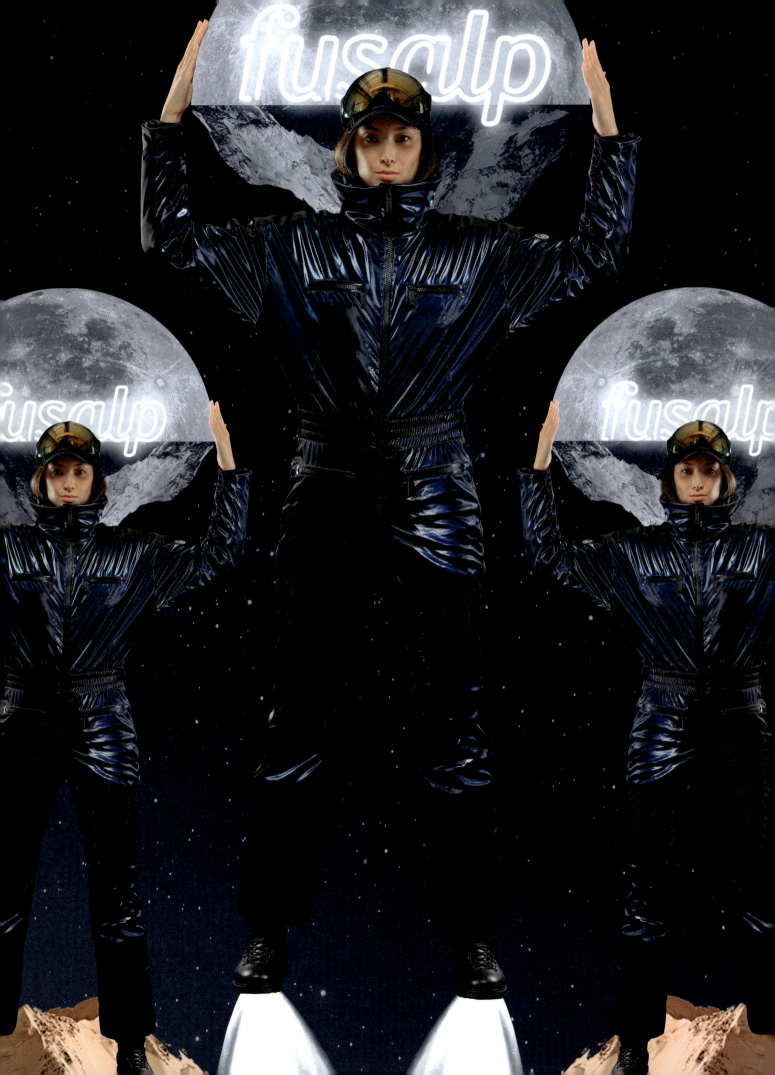

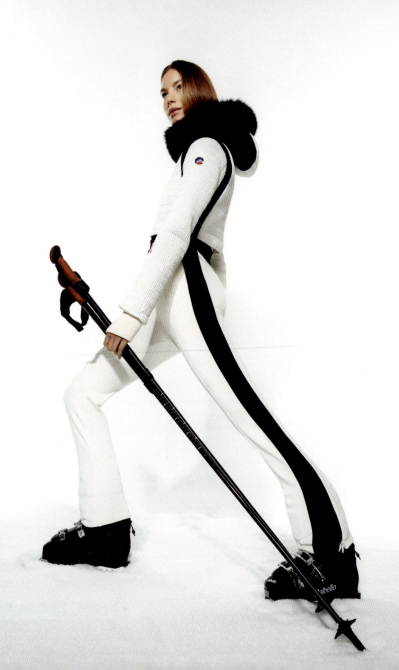

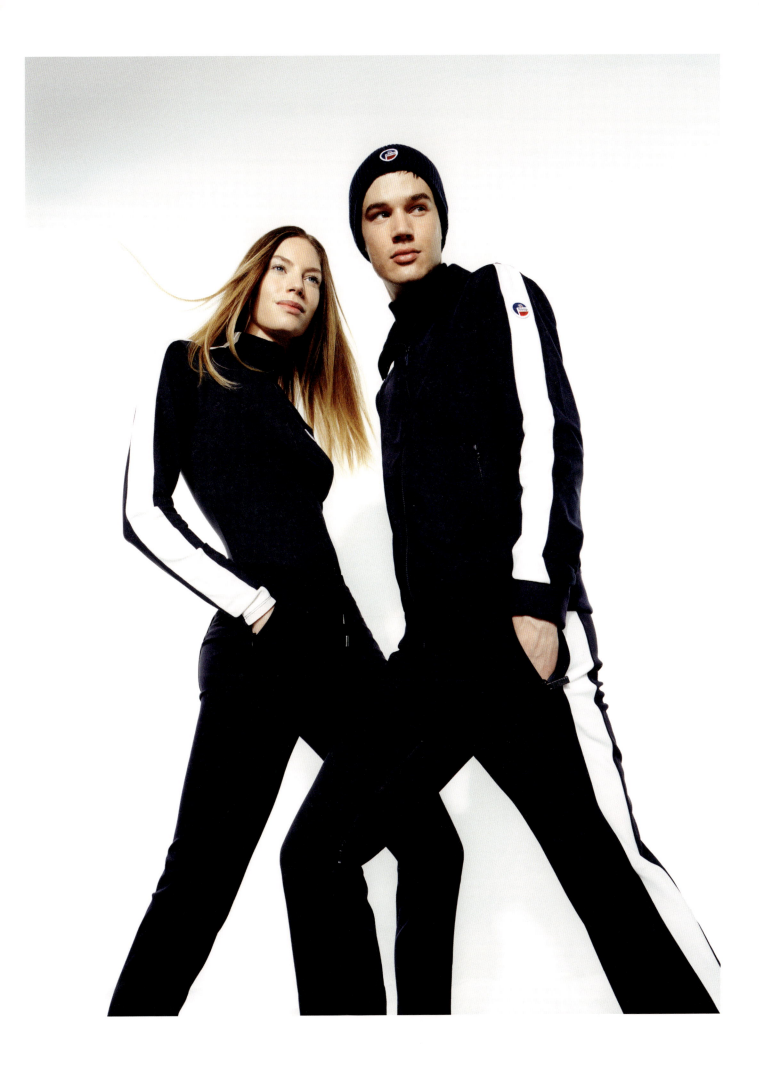

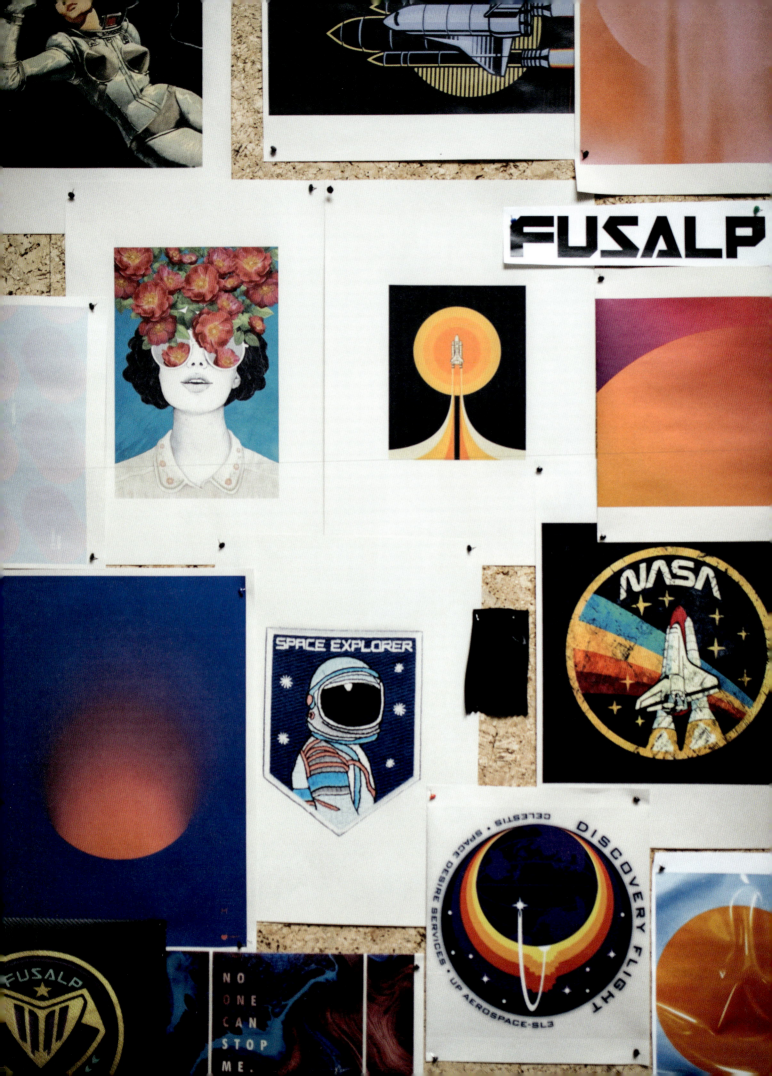

"Existing designs apart the others are outsourced to a 70 year old Venetian model maker who works in a family-run business and who we really depend on for his experience and expertise. I asked him to stitch the seams on articles of summer wear traditionally made on a machine that doesn't exist anymore but that Ingrid Buchner used a lot for detailed work such as creating relief. He happened to have one of these machines in his attic and soon as he'd understood what I wanted, he fetched it and set to work.

"Today our production is equally split between ski outfits and multi-purpose town wear, with our collections expanding every year. The spirit that drives it all, the engine of the business if you like, is this constant interplay between skiwear and streetwear. It's something we started to do at Lacoste but it's infinitely more complex here due to the exacting technical requirements and the types of materials we use. Our strength comes from being a business on a human scale. It means we can talk to people directly, make quick decisions and be as inventive as we like.

Keeping the body in motion is our number one rule for garment construction. People are really starting to dress differently so we look for easy-care materials.

For us, it's all about look and function at the same time!

Previous pages:
Fusalp Autumn / Winter collection 2016-2017.

Left:
"Fusalp Futur": a lunar collection for the future. Mathilde Lacoste takes her inspiration from man's first steps on the moon, now 50 years ago (2019).

❛**Design is like sport: no matter how high you aim, it's still a game.**❜

MATHILDE LACOSTE
ARTISTIC DIRECTOR OF FUSALP

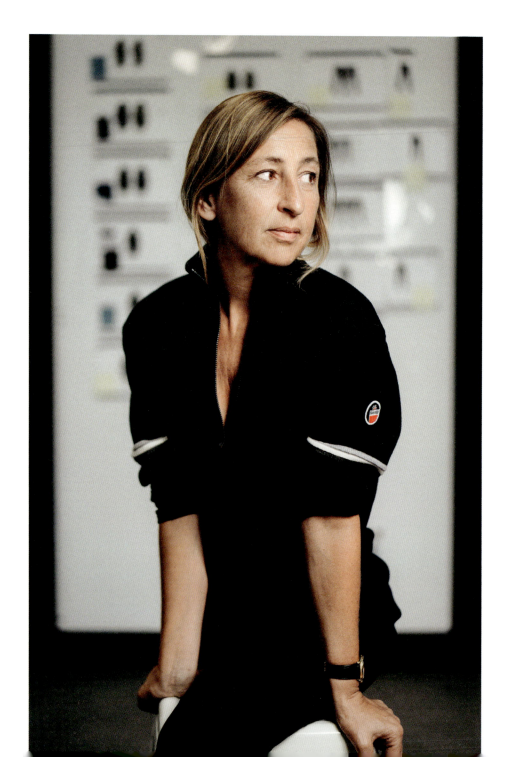

Mathilde Lacoste in her design office in Annecy, 2020.
It all starts with paper, pencils, materials ...

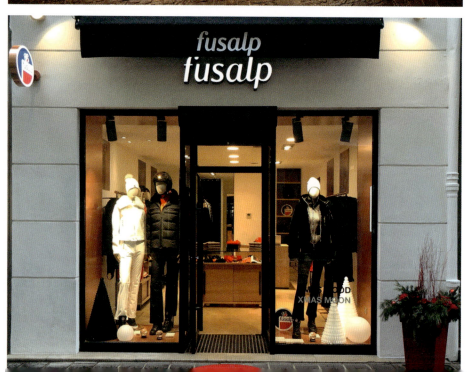

Architect Dillon Garris is master of the architectural concept that defines the brand's boutiques. Unfinished surfaces, oak, copper and black metal.

Left-hand page, from top to bottom:
Luxembourg, Gstaad, Saint-Moritz.

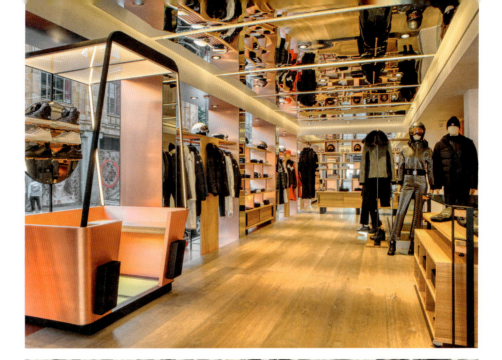

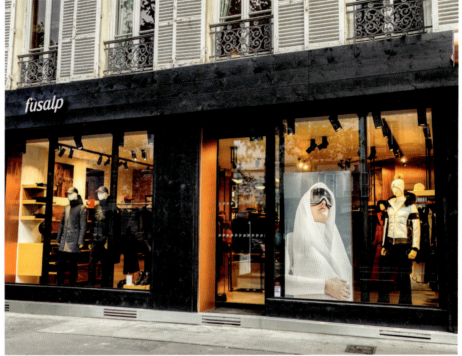

Right-hand page, from top to bottom:

London, Paris Beaumarchais, Beijing.

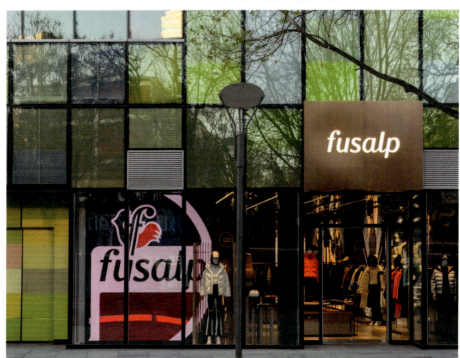

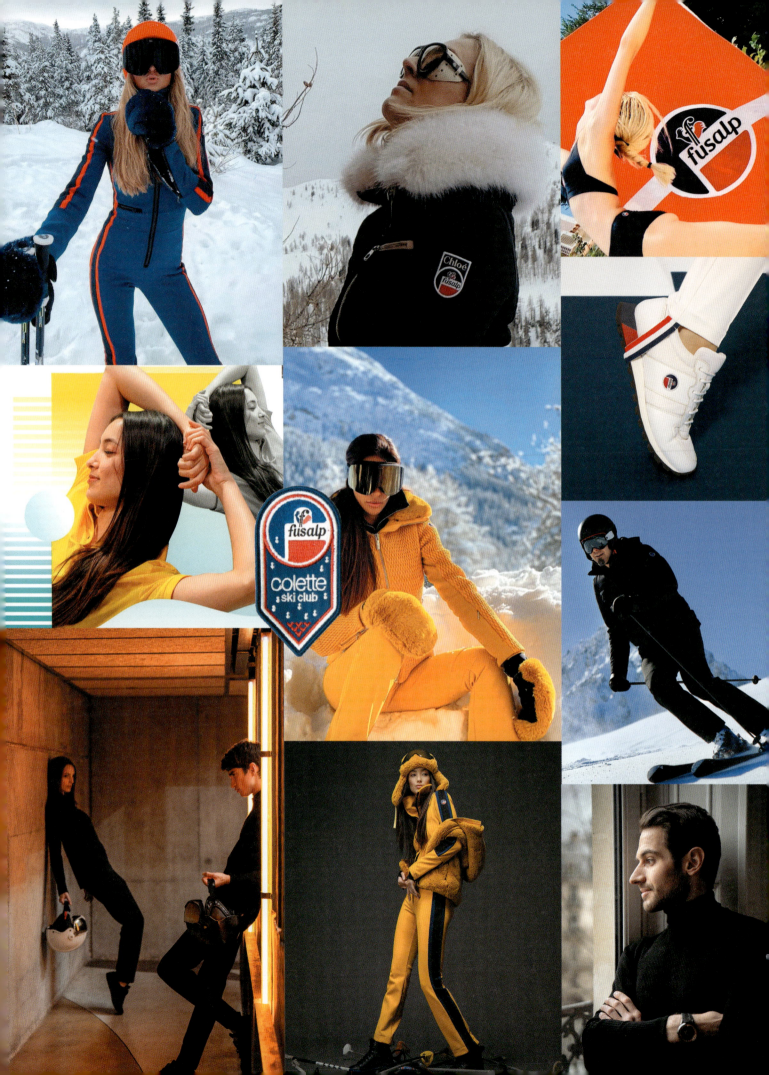

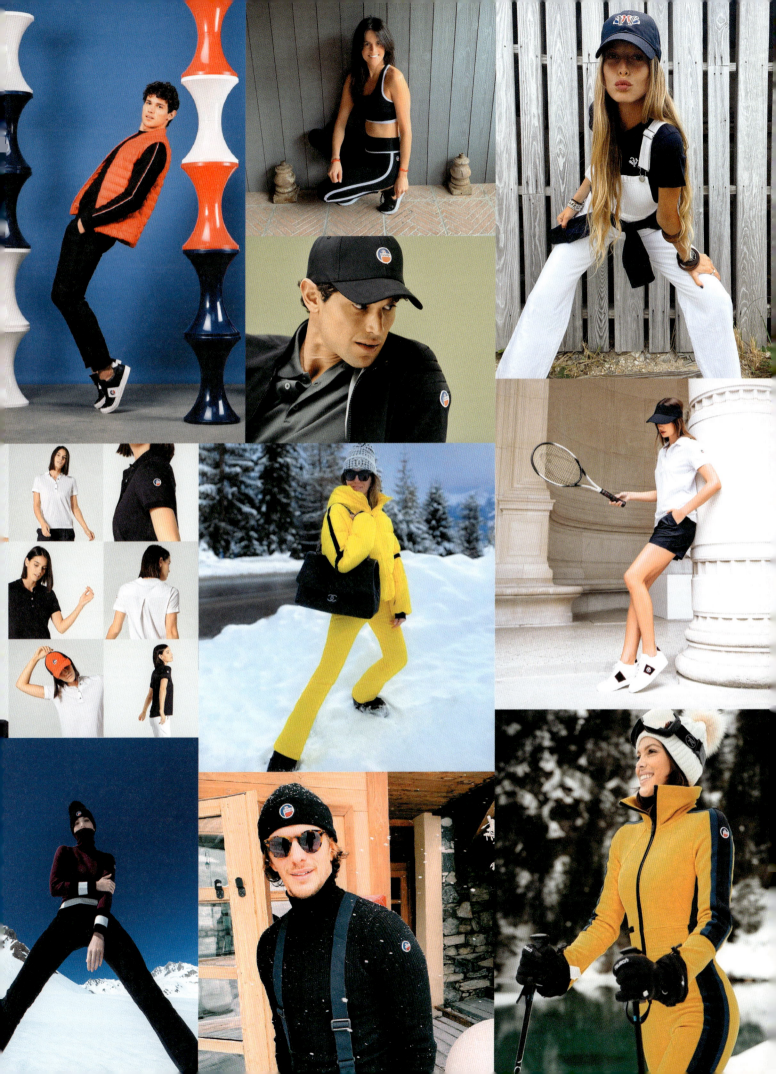

CONCLUSION

There is one event in the history of the brand that has not been covered in this work. In the late 'eighties, a building adjoining the offices close to the factory in Annecy was ravaged by fire, destroying the larger part of the Fusalp archives. Priceless records of Fusalp history perished in flames and it is only thanks to oral history–the surviving memories of the players in this fascinating story of industry–that we have been able to reconstruct the times that shaped our art of movement and innovation.

Fusalp is a brand that defies time and withstands adversity. It has proved that it can bounce back from crisis and reinvent itself whatever the circumstances. As if the perpetual motion that is its calling card kept it moving forward. The year 2014 marked the beginning of a spectacular turnaround built on the legacy of the founders and given new energy by the arrival of a new generation of talent.

As the future unfolds Fusalp will continue to explore new vistas, powered by the energy at the heart of the brand, but ever mindful of our social, environmental and human responsibilities. Expansion into new geographical and stylistic markets must not be at any cost. Fashion can never be separated from politics, which is why Fusalp takes a certain pleasure in pursuing an organic approach focused on caring for others–an approach that spans the generations for the sake of more lasting human relationships.

Fusalp is not even 70 years old. At least, not in its head. The brand has the vigor and daring of a dreamy teenager, turning a deaf ear to all those tired adults who look longingly to the past and think the future is doomed. Ever since the beginning, Fusalp has wanted to create, think up and invent things that don't yet exist. Always for the better.

Today it wants to shape its dreams by following its instincts and going with its wildest ideas. Enjoy playing with that seed of mischief that distinguishes it from the others. Fusalp wants to love, to give and to share. Fusalp wants to believe that tomorrow will be better.

Fusalp is all of those diehard enthusiasts who wrote the first pages of its life and are still writing it today. It is the champion determined to win, the seamstress who loves her garment and the warehouse

CONCLUSION

operator who slips a word of thanks into each box that goes out to a new customer. Fusalp is about people with passion. Fusalp is who we are.

Mathilde Lacoste and Alexandre Fauvet

Ever since the beginning, Fusalp has wanted to create, think up and invent things that don't yet exist. Always for the better.

MATHILDE LACOSTE AND ALEXANDRE FAUVET

Previous pages:
Brand moodboard: campaign visuals, lookbooks, partner events, brand ambassadors and influences.

Left:

Autumn / Winter collection 2021-22.

Right:

Chloé x Fusalp Autumn / Winter collection 2021-22

People-centered business ethics

Fusalp has travelled through the century with its timeless signature intact, drawing on those values that are the very lifeblood of this business. From the moment the new leadership took the reins, it was determined to apply ethical principles across every dimension in the life of the enterprise, whether the conscientious management of human resources or environmental issues. Fusalp is ever aware of the fragile world in which it operates and stands ready to meet the challenges. Hence its commitment to a series of initiatives aimed at building a more sustainable tomorrow, with humanity always at the forefront of its thinking.

Ecological issues loom large in the textile industry and not least for Fusalp, whose entire production chain is geared toward environmentally friendly processes. Following an exhaustive analysis of the company's carbon footprint, materials emerged as the biggest culprit of carbon emissions, second only to transport. Choice of materials is therefore of pivotal importance to Fusalp, which insists on product traceability at every stage of production. What Fusalp makes is made to last with sustainability in mind.

The challenge is collective thinking for collective accountability: uniting all of the key industry players around the table to address the need for transformational change. To which end, Fusalp has recently joined the Fashion Pact, an initiative that brings together global enterprises in the fashion and textile sectors around a core of ambitious environmental objectives with three themes at their heart: climate, biodiversity and oceans.

Fusalp Autumn / Winter collection 2016-2017.

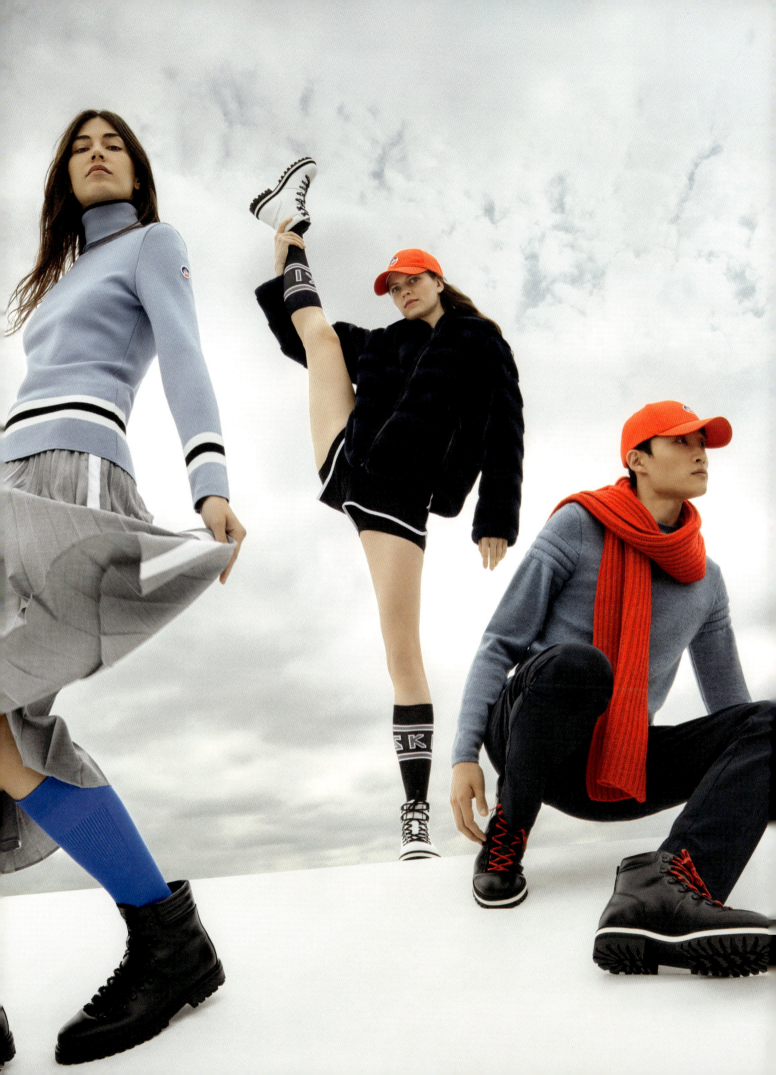

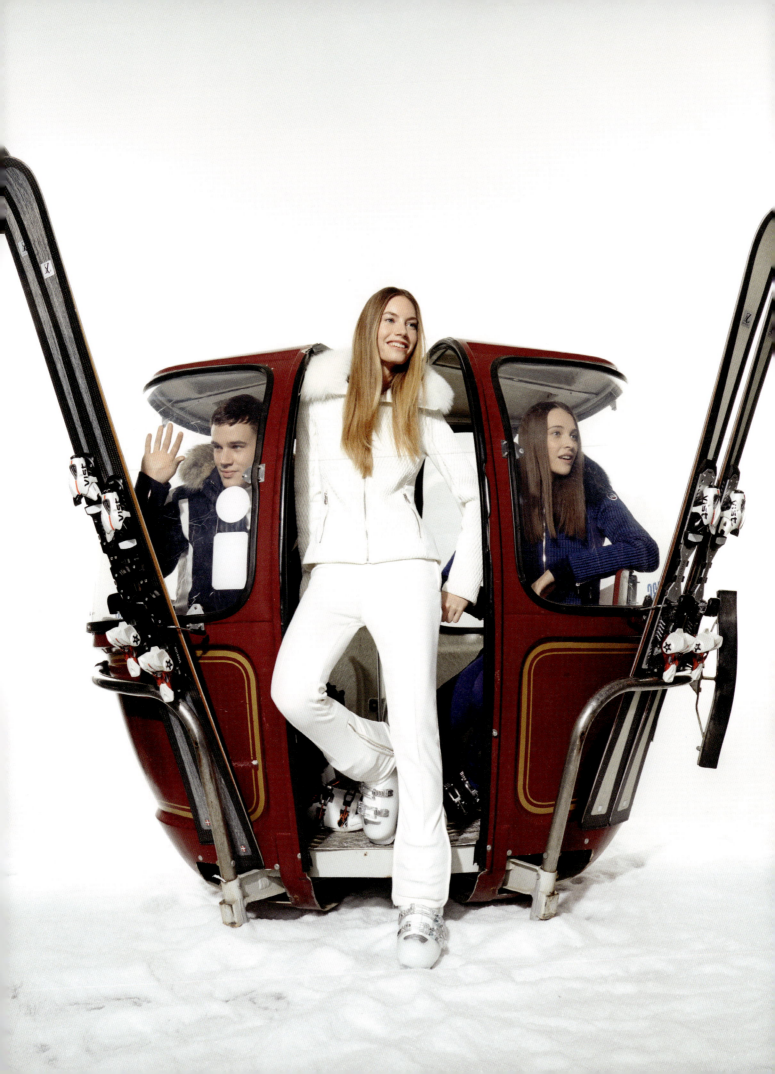

Fusalp's commitment

S ophie Lacoste admits that it is no easy task to build new bridges between the world of business and the worlds of culture and society."The key to realizing our ambitions for society is co-creation and the building of an ethical culture committed to solidarity." This is the thinking behind Fusalp S'Engage: an ambitious philanthropy program launched in 2020 with the mission to support organizations working to protect the environment and improve quality of life for people with disabilities or living in poverty. Worthy causes are put forward by members of the Fusalp "ecosystem"–salaried staff, partners, suppliers–then put to a vote by salaried staff. The selected projects speak to Fusalp's commitment to sustainable development, among them: Baskets aux Pieds, an organization that makes life easier for children in hospital; Sport dans la Ville, which has helped more than 6,500 young people re-enter society and find work; and Naturevolution et ReforestAction, an environment action group that works to protect biodiversity.

Expect more in the same spirit from Fusalp as the years go by, from a brand propelled toward ever expanding horizons by the power of solidarity. It is this commitment to a common goal that will guide Fusalp through the 21st century, keeping the brand relevant but ever faithful to its three founding principles:

Commitment, Optimism and Audacity.

Left:
Autumn / Winter
collection 2015-2016.

Following page:
Bruno Bertrand in
acrobatic action in the
freestyle skiing event at
La Clusaz, 1987.

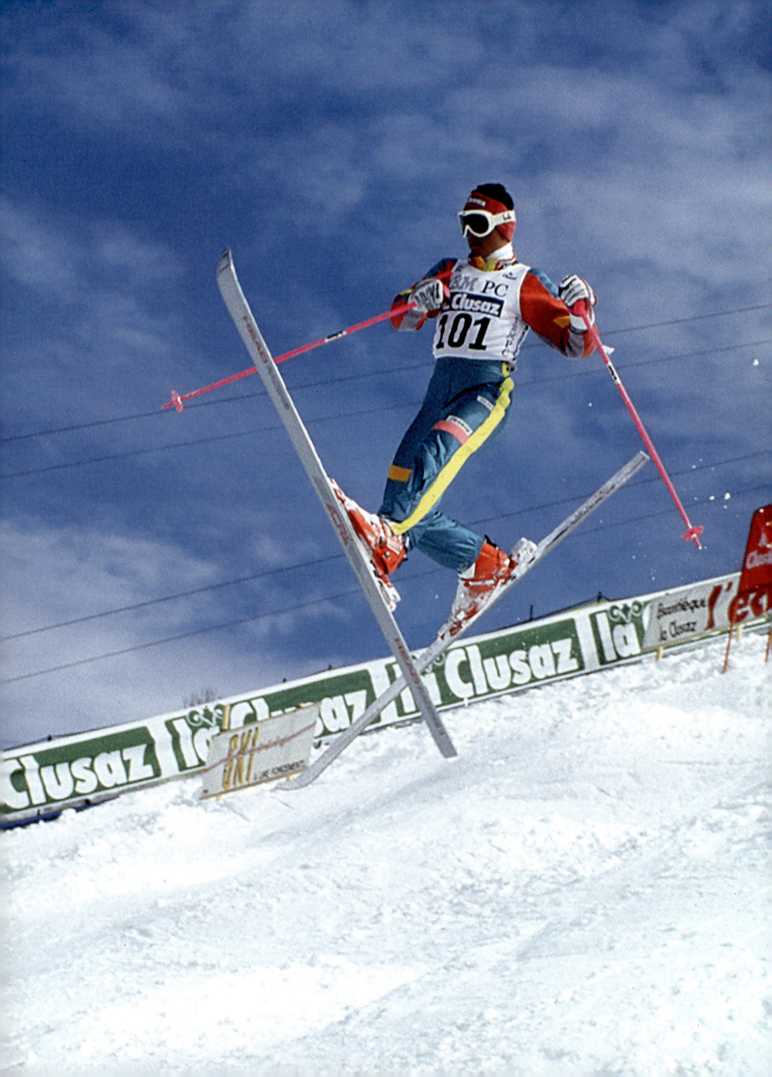

Landmarks in the history of skiing

LANDMARKS IN THE HISTORY OF SKIING

1948

Opening of the first sewing workshop and menswear boutique in Annecy, by local tailors Brunet and Veyrat.

1949

Georges Ribola joins the business as a pattern maker.

1952

14 June 1952, René Veyrat and Georges Ribola get together to create Fusalp, a brand specializing in tailored ski pants. Together with seven seamstresses, they open their first workshop on the Avenue de Loverchy, Annecy. Georges Ribola is in charge of products, René Veyrat handles the financial side.

1956

Fusalp moves to 15, Avenue de Chambéry, Annecy. The factory employs 150 workers.

1960

Launch of the first ready-to-wear women's collection. Fusalp is the official partner of the French ski team and the only technical skiwear brand, part of the French teams' pool of suppliers.

Jean Vuarnet wins gold in downhill skiing at the Winter Olympics in Squaw Valley, California, where he adopts the famous egg-shaped "tuck" position made possible by Fusalp's new stirrup ski pants

1962

Fusalp purchases a former lead works in Albertville and opens its second production site, employing 400 workers.

1964

Innsbruck Winter Olympics in Austria: Fusalp athletes win six medals. Christine and Marielle Goitschel become the first sisters in the history of the Games to secure a one-two finish in the Slalom and the Giant Slalom, but in reverse order.

Arrival of Ingrid Buchner, the stylist who will work with the label for nearly 20 years.

LANDMARKS IN THE HISTORY OF SKIING

1965

Invention of first padded winter pants.

1966

Portillo World Championships, in Chili: Fusalp's first downhill ski suit. The French team takes 16 of the 24 medals, a feat unrivalled by any other country competing in a World Championship.

1968

Grenoble Winter Olympics. French Alpine skiers sporting Fusalp colors take eight medals. Jean-Claude Killy becomes the hero of the Games by winning the three Alpine events.

1972

Sapporo Winter Olympics, Japan: Fusalp gains a foothold in Asia and becomes a global brand.

1974

Opening of fourth production site, in Saint-Jean-de-Maurienne, specializing in children's wear.

1975

Opening of fifth production site, in Rumily, followed by sixth production site, in La Balme-de-Sillingy.

1976

Departure of René Veyrat; Baron Empain acquires a stake in the company. Fusalp acquires French sweater manufacturer "Pulls Montant:" a supplier of sweaters to the French Alpine ski teams and instructors of l'Ecole du Ski Français, known as the "red sweaters."

1978

Departure of Georges Ribola.

1979

Fulsap becomes a world leader in skiwear. Sales hit the 600,000 mark, with a 1200-strong workforce and six production sites in France. Development of summer sportswear collection, including tracksuits, tennis and golf apparel but also "what to wear for boating." Fusalp is appointed a partner to Roland-Garros.

LANDMARKS IN THE HISTORY OF SKIING

1980

First use of subcontracted production for the Italian market. For the Lake Placid Winter Olympics in the US, Fusalp and French Alpine ski racer Perrine Pellen design a new generation of ski suits, tested for airtightness at the St-Cyr-l'Ecole glass works. Pellen takes bronze (France's only medal) and wins the Slalom World Cup 1980.

1981

Fusalp hits a rocky patch due to over-diversification, the arrival of new competitors and an economic crisis that forces business to relocate.

1982

Fusalp is acquired by Le Refuge; newly-appointed creative director breaks with tradition and introduces a collection of cross-country ski clothing.

1984

Fusalp files for bankruptcy and is taken over by four of its executives: Marius Reynoud, Bernard Machillot, Louis Jean and Joël Gleyze, future president and chief executive officer. Renamed Créations Fusalp SA, the brand relaunches with 117 employees. Fusalp makes its last appearance on the slopes, alongside the French Alpine ski teams led by Perrine Pelen, Olympic silver medalist at Sarajevo, and Michel Vion, world champion in the combined event in 1982.

1985

Christine Rossi wins ski ballet Olympic gold, followed in 1988 by the Olympic Championship title (demonstration event)

1986

Establishment of new Head Office in Avenue de France, Annecy.

1990

Creation of new brands Virage, Voltige and Zone Off, specializing in snowboard and freeride ski gear.

LANDMARKS IN THE HISTORY OF SKIING

1991

Launch of No Panik children's wear label

2005

Collaboration with Italian designers; moving up market; creating a more elegant product line; materials development.

2012

Unveiling of "Fusalp 1952" luxury collection at the ISPO Salon in Munich.

2014

Fusalp is acquired by Sophie and Philippe Lacoste and Alexandre Fauvet, who appoint Mathilde Lacoste as creative director. Fusalp teams up with Parisian concept store "Colette" – the most famous concept store in the world – to create a new capsule collection.
Fusalp teams up with Colette Ski Club.

2015

Opening of Fusalp's first Parisian boutique, on the Rue des Blancs-Manteaux in the heart of the fashionable Marais district.

Fusalp wins "ISPO" award for its "Montana" jacket

2017

First international advertising campaign with top model Constance Jablonski. Fusalp opens its "Montagne" flagship store in Courchevel.

2018

Fusalp appointed official partner to the Monegasque team for the Pyeonchang Winter Olympics in South Korea and opens a boutique in Seoul, its first boutique in Asia. Prizewinner at the Landrover Born Awards, Sports category.

2019

Fusalp launches its brand in China.

Creation of "Jeunes Talents" program to support young skiers and athletes, together with the "Fusalp s'engage" philanthropy program.

2022

Beijing Winter Olympic Games. On the occasion of its 70th anniversary, Fusalp becomes official supplier to the British Alpine ski squad

ACKNOWLEDGEMENTS

First off, our heartfelt thanks to Joël Gleyze for having
entrusted us with the destiny of Fusalp.
A big thank you to all those who took part in putting together this
fabulous story and agreed to share their experiences here, together
with all of those people who so warmly welcomed us in 2014:
Pascal Aymar, Daniel Brunier, Christophe Catherine, Franck
Compagne, Johann Duthilleul, Ophélie Evrard, Christelle Gachet,
Elsa Mombelli, Odile Renard, Jean-Charles Starfach, Pierre-Olivier
Verley and Yannick Vignot.

And our most sincere thanks to the Fusalp team for joining us in this
endeavor to build a solid and promising future for the company.

Lastly we wish to extend our gratitude to the people who have
made this book possible: Mohamed El Khatib, Yohanne Lamoulère,
Vassia Chavaroche; and the team at Éditions de La Martinière:
Gislaine Yvinec, Corinne Schmidt, Emmanuelle Halkin, Virginie
Mahieux; Coco Casting also Camille Dujardin and translator
Flo Brutton.

Mohamed El Khatib extends his warmest thanks to the people who
supported him in writing this book:

Nadine Portigliati and Stéphanie Bouchet;
Ingrid Buchner and Mathilde Lacoste;
Joël Gleyze, Claude Lavorel and Raymond Bara;
Rose-Marie de Olivera, Séraphin Vinco and Elisabeth Malcor;
Léo Lacroix, Marielle Goitschel, Annie Famose, Christine Rossi and
Perinne Pelen, Claudia Riegler-Dénériaz and Antoine Dénériaz;
Léonard Holzer and Fabian Nagy for the archival research;
Sophie and Philippe Lacoste;
Alexandre Fauvet; Vassia Chavaroche
and the entire Fusalp team.

PHOTO CREDITS

p.4-5:© Fusalp records/All rights reserved
p.6-7:© Fusalp records/All rights reserved
p.8-9:© Fusalp records/All rights reserved
p.10-11 :© Photos Lars Pillmann
(www.pillmann.com), models: Shanna Keetelaar
Marguerite Piard - Caroline Goeckel
p.18-19:© Stéphanie Bouchet
p.28-29:© Stéphanie Bouchet
p.30:© Fusalp records/All rights reserved
p.32:© Fusalp records/All rights reserved
p.34:© Fusalp records/All rights reserved
p.35:© Fusalp records/All rights reserved
p.38:© Fusalp records/All rights reserved
p.40, 41:© Fusalp records/All rights reserved
p.42-43:© Fusalp records/All rights reserved
p.45:© Fusalp records/All rights reserved
p.46, 47:© Fusalp records/All rights reserved
p.48:© Fusalp records/All rights reserved
p.51:© Photo12/Alamy/Archive PL
p.52:© Fusalp records/All rights reserved
p.54:© Bridgeman Images
p.55:© Fusalp records/All rights reserved
p.57:© Fusalp records/All rights reserved
p.62-63:© Amarcster Media
p.64:© Keystone-France/Gamma-Rapho
via Getty Images
p.65:© Benjamin Souriac
p.70-71:© Natacha Rottier
p.72:© Fusalp records/All rights reserved
p.75:© Fusalp records/All rights reserved
p.76:© Fusalp records/All rights reserved
p.86-87:© Stéphanie Bouchet
p.88:© Fusalp records/All rights reserved
p.91:© Fusalp records/All rights reserved
p.92:© Fusalp records/All rights reserved
p.95:© Fusalp records/All rights reserved
p.96:© Fusalp records/All rights reserved
p.98-99:© Fusalp records/All rights reserved
p.104-105:© Stéphanie Bouchet
p.106:© Fusalp records/All rights reserved
p.109:© Fusalp records/All rights reserved
p.110:© Fusalp records/All rights reserved
p.113:© Fusalp records/All rights reserved
p.114, 115:© Fusalp records/All rights reserved
p.118, 119:© Fusalp records/All rights reserved
p.120-121:© Fusalp records/All rights reserved
p.122-123:© Fusalp records/All rights reserved
p.124:© Photos Lars Pillmann (pillmann.com)
p.127:© Photos Lars Pillmann (pillmann.com)
p.128:© Photos Lars Pillmann (pillmann.com)
p.132-133:© Thomas Béhuret
p.139:© Stéphanie Bouchet
p.140:© Drew Vickers - Art Director:
Franck Durand, Model: Hana Jirickova
p.143:© Michel Sedan, Model: Barry Lomeka
p.148:© Michel Sedan,
Model: Constance Jablonski
p.149:© Production and Art Director:
Studio Lamadone, Photography: Studio
Picabel, Models: Alexander Ferrario and
Hélène Muccioli
p.151:© Nathaniel Goldberg,
Model: Constance Jablonski

p.154-155:© Production and Art Director:
Studio Lamadone, Photography:
Studio Picabel, Model: Alexander Ferrario
p.156:© Drew Vickers, Art Director: Franck
Durand, Model: Hana Jirickova
p.164:© Production and Art Director: Studio
Lamadone, Photography:
Studio Picabel, Model: Stephanie Jackson
p.168-169:© Studio Picabel,
Mannequin: Tiana Tolstoi
p.171:© Production and Art Director:
Studio Lamadone, Photography:Studio Picabel
p.172:© Production and Art Director:
Studio Lamadone, Photography: Studio Picabel
p.173:© Marine Billet, Model: Zoé Léger
p.174:© Production and Art Director:
Studio Lamadone, Photography:Studio Picabel
Model: Hélène Muccioli
p.176:© Studio Picabel, Model: Tiana Tolstoi
p.177:© Drew Vickers, Art Director:
Franck Durand, Model: Hana Jirickova
p.179:© Studio Picabel, Model: Tiana Tolstoi
p.180:© Photos Lars Pillmann
(www.pillmann.com), Model: Shanna Keetelaar
p.181:© Photos Lars Pillmann (pillmann.com),
Models: Shanna Keetelaar, Brieu Morel
p.184:© Théo Saffroy
p.186-187:© Maxim Burlakov
p.188-189: From left to right, from top to
bottom: @camillaabry @vibeshunter-Florence
Cazal © Studio Picabel, Model: Giacomo Cavalli
@mumdaymornings © Studio Picabel, Model:
Giacomo Cavalli @pamelatick
@sandraackerl @flaviastuttgen
@indianarasigon @indianarasigon © Studio
Lamadone/Studio Picabel, Models: Alexander
Ferrario et Héléne Mucciolli © Studio Picabel,
Model: Tiana Tolstoi © Julien Poupart, Model:
Mathieu Faivre © Studio Lamadone, Model:
Hélène Mucciolli @Jakehall @irismittenaeremf
p.192-193, 195:© Koto Bolofo,
Models: Riu Wankyu, Marilhéa Peillard,
Nataliya Bulycheva
p.196:© Photos Lars Pillmann (pillmann.com),
Models: Brieu Morel, Shanna Keetelaar, Olga
Pashievska
p.198:© Fusalp records/All rights reserved

p.20, 22, 25, 26, 37, 60, 61, 67, 68, 78, 79, 80,
82, 83, 85, 102, 117, 130, 137, 145, 146, 153, 159,
160-161, 163, 167, 182, 185, 204:© Yohanne
Lamoulère

Cover: © Studio Picabel, Model: Lili Marie
© Yohanne Lamoulère

Despite our best efforts, it has not been
possible to locate all of the copyright holders
and models featured in this book. We
apologize in advance to those concerned
and assure them that in the event payment
will be forthcoming.